IMAGES
of England

SUDBURY

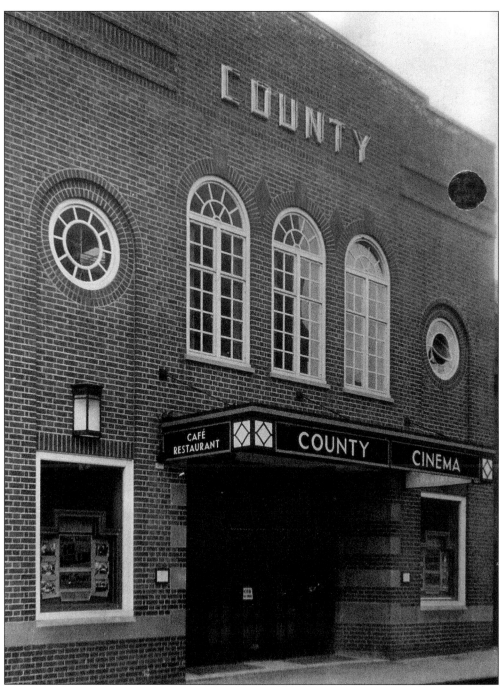

The demolition of the County cinema in the 1970s is still regarded as a capital loss to Sudbury by those who remember it. Apart from a dignified neo-Georgian façade which was planned so as not to detract from the medieval church opposite, it was decorated throughout in a quiet, classical Adam style. Today it would warrant a Grade II listing. Sadly, it has not been possible to trace any photographs of the interior.

IMAGES
of England

SUDBURY

Compiled by
Barry Wall

TEMPUS

First published 1998
Copyright © Barry Wall, 1998

Tempus Publishing Limited
The Mill, Brimscombe Port,
Stroud, Gloucestershire, GL5 2QG

ISBN 0 7524 1557 3

Typesetting and origination by
Tempus Publishing Limited
Printed in Great Britain by
Midway Clark Printing, Wiltshire

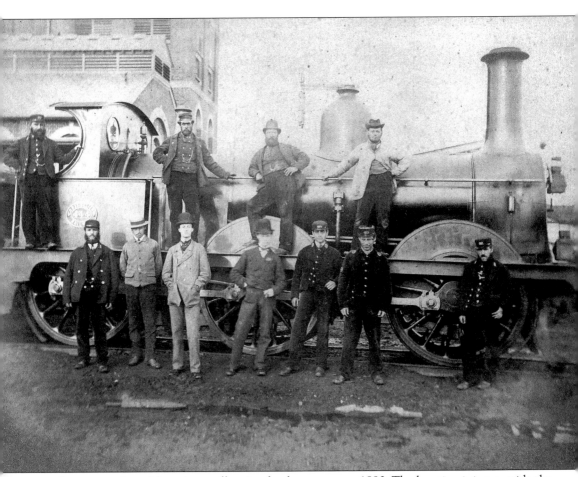

A steam engine with station staff posing for the camera, *c.* 1890. The location is just outside the original Sudbury station which stood close to Oliver's Brewery off the Cornard Road.

Contents

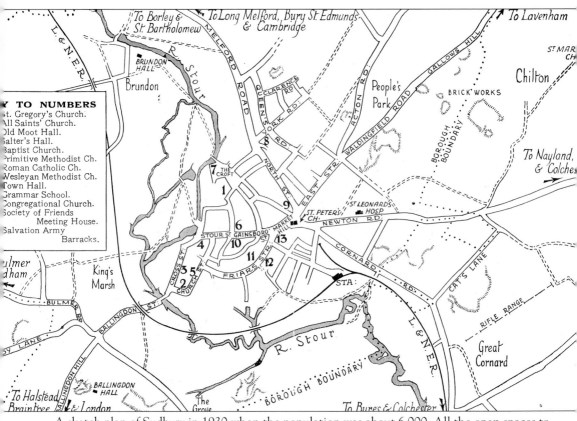

A sketch plan of Sudbury in 1930 when the population was about 6,000. All the open spaces to the north and east are now built upon and only the flood plain has prevented the town from expanding in other directions. The population has since trebled.

Introduction

Sudbury in Suffolk is a historic town. Its name means 'south fortification' and the town was so named by the Saxons who had indeed settled in an Iron Age fortified camp. From that settlement grew a prosperous medieval market town with a full complement of religious foundations, three parish churches, two priories, an ecclesiastic college, two hospitals and a grammar school. The prosperity of the town is due to its ancient market, to its geographical situation in the Stour Valley, which made it an important centre for agricultural commerce, but most of all to the woollen cloth trade.

With the Reformation and the closure of the religious houses, Sudbury's fortunes began to change. Changes came slowly at first, but towards the close of Elizabeth I's reign came the rapid decline in the cloth trade in this part of the country. Throughout the seventeenth century weaving continued on a much-reduced scale and, as records show, it was mainly the cheaper 'says and bays' and eventually bunting. Defoe reported that he knew nothing about the town 'except that it be very populous and very poor' and that 'the poor were ready to eat the rich'.

The fortunes of the town were reversed again in the eighteenth century, when by special Act of Parliament the River Stour was made navigable from Sudbury to Manningtree. It was one of the first rivers in the country to be made navigable for barge traffic. Work began in 1705 and the Sudbury quay appears to have been operating eight years later. The farmers were able to get their produce up to the fast-growing capital and to ship their barley down-river to many maltings which sprang up. The barges brought back to Sudbury the much-needed coal. In the nineteenth century vast quantities of bricks were sent downstream to the coast where they were transferred to coastal barges and taken to Chelsea Wharf. Many London buildings are constructed with Ballingdon bricks, especially in South Kensington.

At the end of the eighteenth century, silk weaving was introduced from Spitalfields, first of all in the weavers' homes and later in factories. One of the most distinctive types of house in Sudbury is the weaver's house of the nineteenth century. They were built in terraces and were three storeys high, their most notable feature being the large window to light the loom on the first floor. A large area of the medieval town was cleared for these terraces, mainly along Gregory Street and The Croft, while others were built on the edge of the town in East Street, Ballingdon, Batt Hall and Melford Road.

The railway arrived in Sudbury in 1849 and engaged in fierce competition with the river transport. When the line was extended to Cambridge an iron bridge carried the trains over the entrance to the quay. The last barge to use the quay left in 1914. There is no doubt that the railway was an important factor in the great expansion of Sudbury in the second half of the nineteenth century. New industries sprang up and the town almost doubled in size. The brickworks were kept busy as demands for bricks increased; the majority of the houses were constructed with Ballingdon whites, which weather to an attractive grey.

Agriculture was vastly improved in the eighteenth century, especially in East Anglia. Arthur Young, the famous agriculturist, was born only twelve miles away. However, in the twentieth century this industry suffered much during the depression and once again poverty was not far away. The brickworks closed and one by one the lime pits ceased to function. Greene King took over Oliver's brewery and eventually closed it. During the Second World War an airfield was built on the edge of the town where the Americans were stationed. The silk factories made parachutes and there was a great demand for food and gravel. Just as bunting was needed for the navy in the eighteenth century and therefore kept Sudbury busy, so the war became Sudbury's salvation again.

After the war, during the 1960s, two things happened that were to have an enormous effect on the town. First was the arrival of the 'overspill' from London into Great Cornard and Sudbury, which entailed the building of large housing estates; the second was the reorganization of local government when the town lost its borough status. Since the war, Sudbury has also had to face up to the increased use of the car, which more than anything has changed the face of the town. As this book goes to press, a controversial scheme to make North Street pedestrian-friendly is under way and the townspeople wonder if they will ever get their long-promised bypass.

The street pattern of Sudbury reveals very clearly how the town has evolved from an Iron Age fort to a Saxon and medieval town, and there are some remarkable buildings from each period of its development since then. However, early pictures of the town – from before 1850 – are extremely rare, in spite of the fact that one of England's greatest painters, Thomas Gainsborough, was born here. Though one of his great masterpieces in the National Gallery shows a Ballingdon girl with her Bulmer husband (Mr and Mrs Andrews) and two Sudbury girls, his daughters, we long to know what the other Sudburians looked like. There is no doubt that one of the greatest inventions in the eyes of the historian has been the camera.

In this book I have assembled a collection of photographs which recapture the town as it was from the mid-nineteenth century onwards. I begin with sections showing the town centre and old town streets. Then there are sections showing the town celebrating national and local events, sports and pastimes. It finishes with a series showing the great changes which took place in the 1960s; these more than any of the others show how important a photographic archive is. These changes have accelerated in the past twenty years and the camera has been there to record them for future generations as they happened. The town's boundaries have restricted and directed the pace of development so that most of it has been to the north and east and while we may regret the passing of those open fields, the old town has remained relatively intact. The postcard views from the early 1900s prove that fact, as will be seen. Compared with other towns of its size, Sudbury has come through the past century in pretty good shape.

A great many of the photographs, at least a hundred, have been supplied by Mr H. Griffiths of Great Cornard, who has made it his task to keep a photographic record of any pictorial references to Sudbury, especially postcards. Many local collectors have loaned him material for that purpose and we have to thank him and them for their valuable contribution. The remaining material has been drawn from the collection of the Sudbury Museum Trust and my own files.

If I have a favourite from amongst them all, it has to be the beautiful, evocative image from the early 1920s of Layzell's mobile shop – horse-drawn, trundling down the Suffolk lanes. It was sent to me through the post twelve years ago and I cannot recall thanking the sender. I do now and I hope they will be as pleased and proud as I am to have contributed to this edition of the Archive Photographs Series.

Barry L. Wall, June 1998

One
The Market Hill

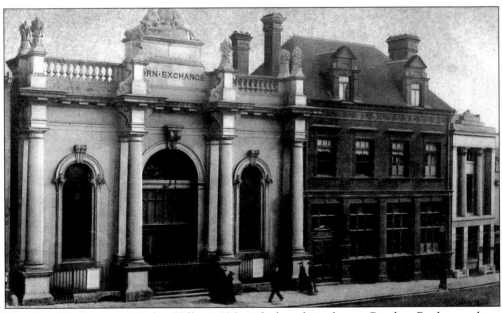

The Corn Exchange on Market Hill in 1905, with the relatively new Barclays Bank next door. On the extreme right is the Literary and Mechanics Institute, established in 1843. Now known as The Institute Club, it has since moved to the old *Free Press* office in Station Road.

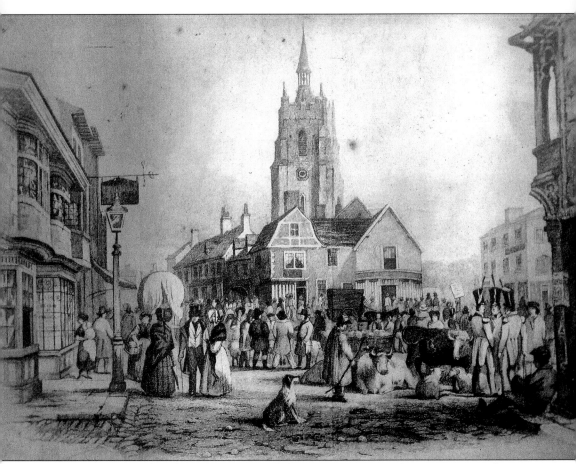

Views of Sudbury before the advent of photography are scarce. This is a nineteenth-century photograph of an engraving, the origin of which is obscure. It has been reproduced in different forms many times, especially as a picture postcard at the turn of the century. The Market Hill is shown as it was before the demolition of the Moot Hall in 1840 and the removal of the houses surrounding St Peter's church in 1843. However, the gas lamp on the left could not have been there at the time and its presence in the picture tells us that it has been drawn from memory. On the extreme left is the Black Boy with the corner post of the Moot Hall immediately opposite. To the right of the church is the bulk of the Rose and Crown, Sudbury's foremost inn at that time. The artist has presented us with a somewhat romanticized view of the town centre, which was in fact unpaved, overcrowded, smelly and lacking drainage. All was changed by special Acts of Parliament in 1826 and 1842, 'for the paving, lighting, cleansing, watching, watering and improving of the Borough of Sudbury'.

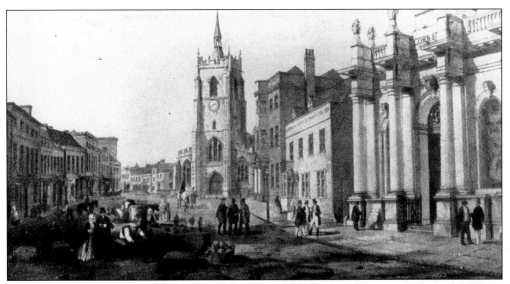

Almost the same view in 1843, showing the dramatic consequences following the Act. Sudbury has acquired an impressive town centre space and a handsome new Corn Exchange of classic proportions on the site of the old Coffee House inn. The shops on the left have been refronted and apart from the church there is little sign of the town's medieval origins.

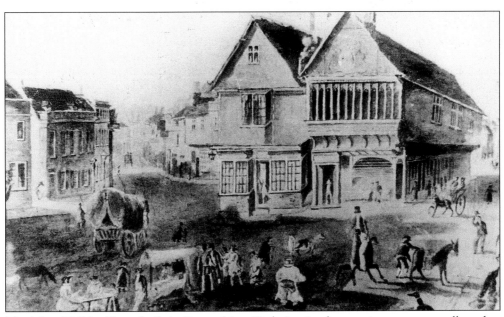

The Moot Hall had been built in Queen Mary Tudor's reign but sentiment was not allowed to prevent its replacement by a new building in the Greek style on a new site.

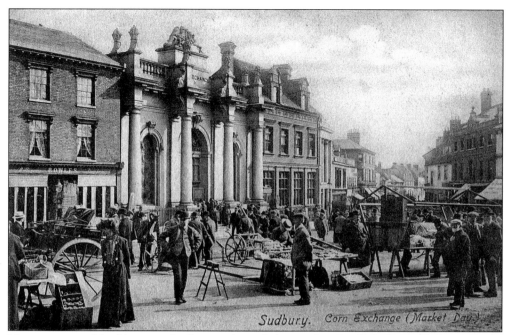

New commercial buildings gradually transformed the south side of Market Hill: for example, Barclays Bank, which was completed in 1879. This postcard view of 1900 shows market day activity. Sudbury has had a market since Saxon days when it was held on a site in Stour Street.

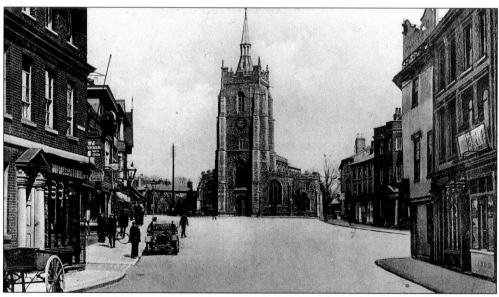

Ten years later, a solitary motor stands on the Hill. The telegraph pole beside the church became a local landmark for fifty years.

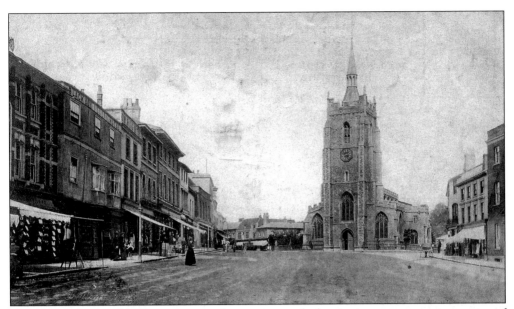

This postcard view of 1890 is interesting because not only does it give an accurate impression of the spacious expanse of the Hill without traffic, but it also shows the Black Boy on the left before the refronting of 1900-1901.

The bottom of the Hill, 1870. This is probably the oldest photograph known of this view. The Georgian façade of the Black Boy is clearly seen on the right and beside it stands a timber-framed house soon to be demolished to make way for a new shop built with Ballingdon bricks (this can be seen in the previous picture). The corner shop on the extreme left was soon to be engulfed by Andrew's Bazaar.

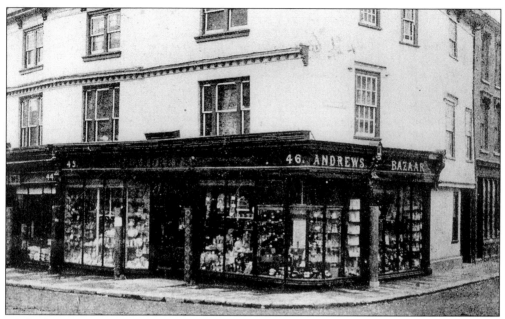

Andrew's Bazaar was Sudbury's first department store. In 1890 it expanded and took in the corner shop where Midland Bank now stands. They commissioned a special commemorative plate from Minton to celebrate the event.

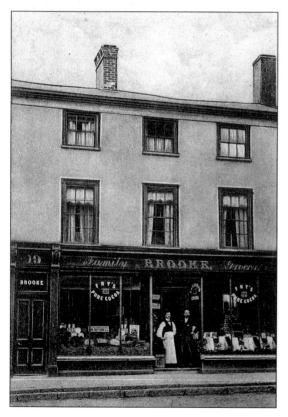

Most of the buildings on the north side of the Hill were gaining new shop fronts from 1880. Here is Brooke's the grocers, which has since changed hands many times and during the 1940s became the International Stores. It is now a supermarket and still selling groceries.

This magnificent shop front was erected about 1815 with a pedimented doorway shared with its neighbour. It would look equally at home in St James's, London, or in Bath. It survived intact until the 1920s and now only slight traces remain. However, although both properties have changed hands, they are still occupied by a newsagent and a jeweller. A remarkable instance of continuity – but not unusual in Sudbury.

W. G. CHANDLER,

PRACTICAL WATCHMAKER,

JEWELLER, SILVERSMITH,
OPTICIAN, ENGRAVER.

CHOICE STOCK .

Gold Watches, Gold Guards,
Gold Brooches,
Silver Brooches,
Silver Novelties, Electro Plate.
Silver SOUVENIR SPOON, 5/6.
EXTRA HEAVY SPOON,
Richly Enamelled, 6/6.
Personal Attention to Repairs of every
Description.

18, Market Hill, SUDBURY, Suffolk.

4

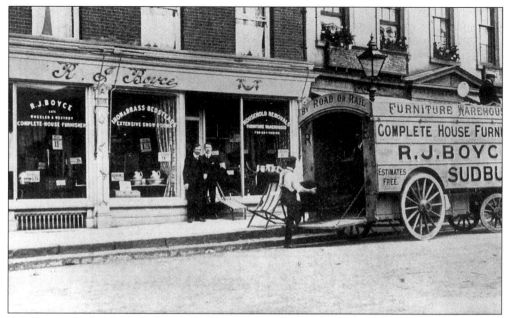

R.J. Boyce, the house furnishers next door, was sold to P.S. Head and continued in the same trade until the 1970s. It is now a menswear shop owned by a national chain and the elegant Edwardian shop front has been replaced.

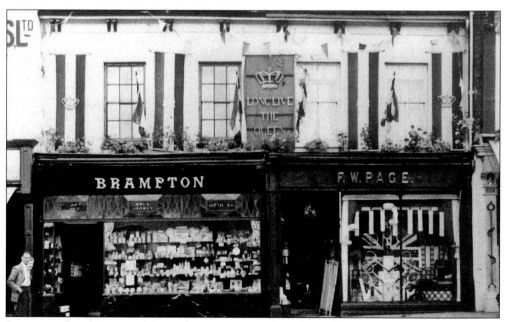

Brampton the chemist and Page the ironmonger shared a building of considerable antiquity. Shown here in 1953, Page's frontage is still Edwardian but Brampton's was altered in the 1930s. The building was almost demolished except for the façade and now houses Boots the chemist's.

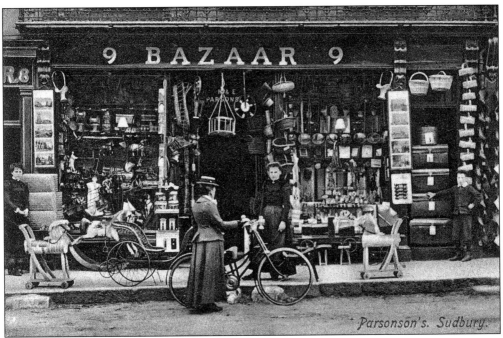

Parson's Bazaar occupied No. 9 Market Hill in 1900. It sold just about everything, as can be seen here, but was never a serious rival to Andrew's Bazaar just a few yards away. The Parsons were an old Sudbury family with shops in other parts of the town, such as a basket shop in Friar's Street and a tailor's shop at the foot of the hill.

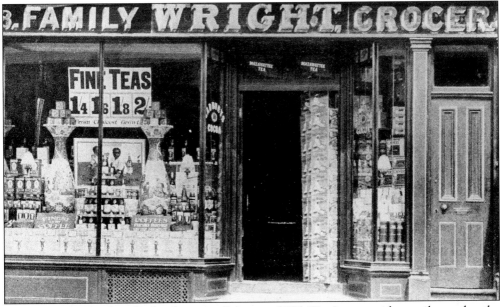

Next door was Wright's the family grocer. It became E.W. King's grocery shop and passed to the Kisby family, who own it still. It has become as familiar a part of Sudbury as St Peter's church in spite of the advent of the huge supermarkets. Apart from the name on the fascia, the shop front has remained intact. It would seem that there has been a family grocer here for over 130 years.

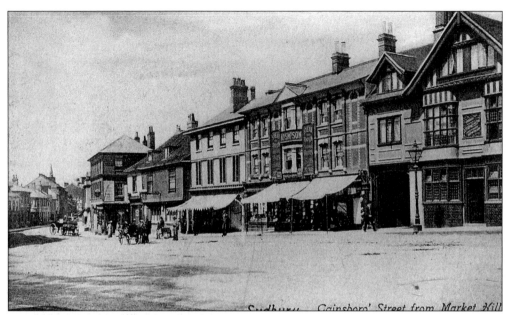

The Black Boy with its newly erected façade in 1901. All traces of the Georgian features have been removed and the medieval inn has been restored back to what the Edwardians thought it should be. During the alterations a fine Jacobean fire surround and overmantel was removed from the parlour and re-erected at Salter's Hall in Stour Street, where it remains.

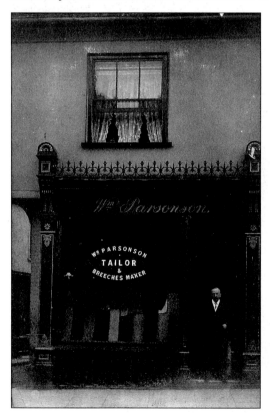

Mr Parsons stands outside his tailor's shop at the foot of the Hill on the corner of Burkitt's Lane in 1905. It is a typical Victorian shop with free use of cast iron above and below. It is possible that it may have survived behind the present fascia. For the past fifty years at least the premises have housed a shoe repair service.

This narrow-fronted shop on the south side of the Hill shows a Victorian cake shop at its most elegant. It became Andrew's bakery and teashop and survived as such until the 1960s when everything below the balcony was ripped out and replaced with an ugly shop front. It has now become the home of a building society and a more acceptable front has been installed, but those who remember the original will always regret its passing.

The last remaining Georgian shop on the Hill, one of an identical row of six, was removed as recently as 1998 and re-erected at the side of the building. This is an example of how a photograph from this year can become a historic archive feature overnight.

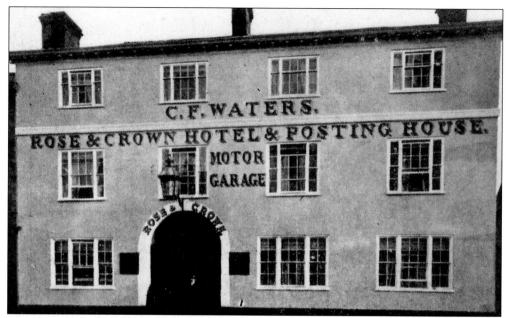

Two views of the Rose and Crown Hotel, one of the great coaching inns of East Anglia, dating from the sixteenth century. The original structure is hidden beneath later Georgian work, but the great glass-covered courtyard is obviously a major attraction. It all went up in flames on the morning of New Year's Day 1922 together with the adjoining shops in King Street. Had the wind been blowing in the opposite direction, the whole of the south side of Market Hill would probably have been destroyed.

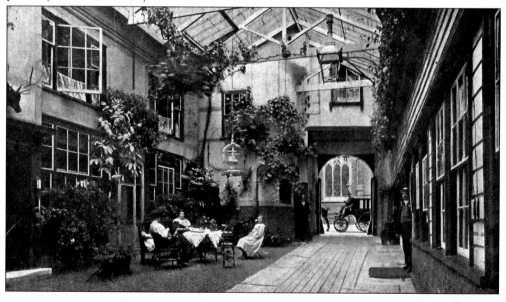

It was the worst recorded fire ever seen in Sudbury. Manchester House in King Street, a large drapery emporium, was completely destroyed and there was a real danger that the nearby Wheeler's timber yard would also be consumed. Dixon Scott also had oil and gunpowder stored on their premises which were not many yards away. In daylight the scene of devastation shocked the inhabitants. Fire crews from as far away as Colchester attended the blaze but there was a shortage of water and it took a long time to fix up a hose long enough to reach the river in Meadow Lane. The best they could do was to contain the blaze and prevent it from spreading.

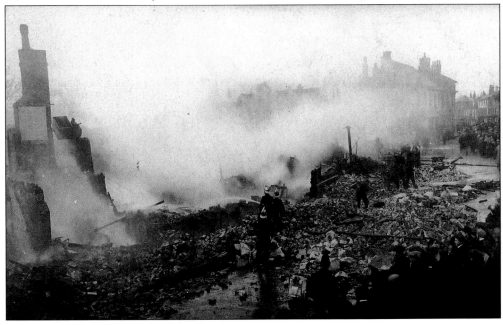

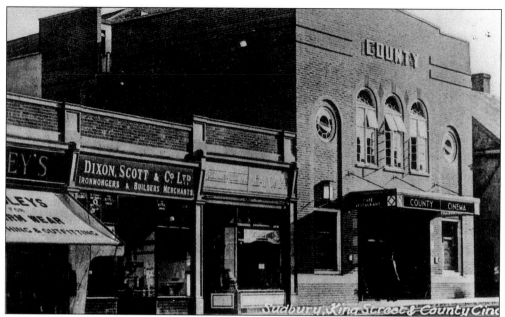

The site of the Rose and Crown stood vacant for over ten years and then from the ashes rose the County cinema and a parade of lock-up shops. It was well designed with a spacious foyer and a large restaurant on the first floor. With the introduction of television, attendance fell and the cinema, like so many others, was demolished to make way for a supermarket in the 1960s. It was taken over by Winch and Blatch. The parade of shops is all that remains to remind us of the cinema and the extent of the blaze in 1922.

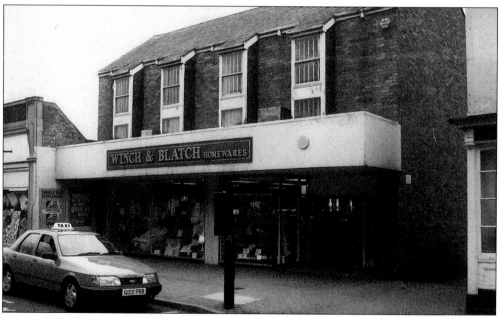

Two

North Street

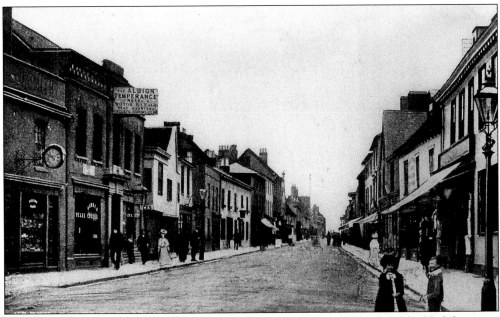

North Street from Old Market Place, with no traffic in sight, in 1906. The old gabled shop next to the Albion Temperance Hotel was demolished in the 1960s when it had been Mr Mead's barber shop for many years. The Four Swans further up had been the Lion a few years previously; it was burnt out in 1997.

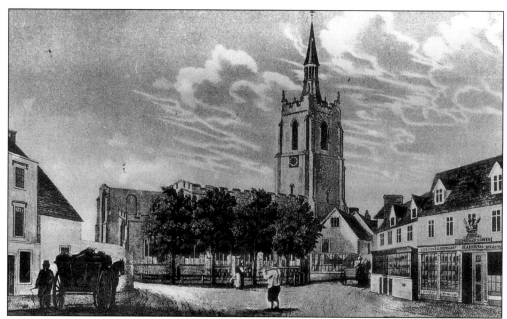

North Street begins at Old Market Place, to the north of St Peter's church. It marks the main entrance to the medieval town from Bury and Melford. It was the town's main shopping street after Market Hill. This old print shows the Old Market Place around 1820 after the removal of the Butter Cross and some of the houses which surrounded the church.

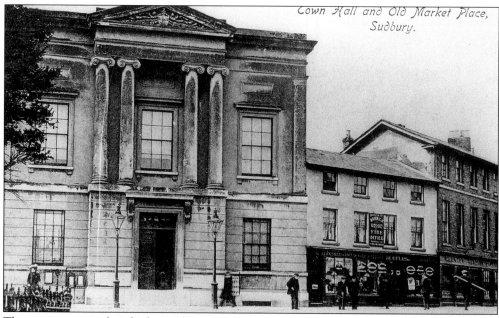

Town Hall and Old Market Place, Sudbury.

The same view one hundred years later. The Town Hall stands on the site of the Chequers inn and was built by a Sudbury man named Thomas Ginn. The shops have an additional top floor.

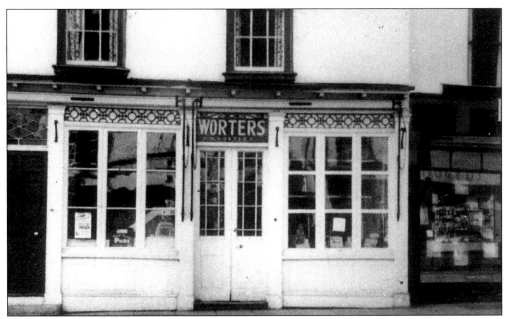

Mr Worter's butcher's shop in North Street as it had survived until 1960. The shop was taken out to provide an extension to the Radio Supply shop next door. During the alterations a beautifully carved Bressummer beam was uncovered but sacrificed for the new fascia. During the 1970s the building was demolished except for its façade, which remains.

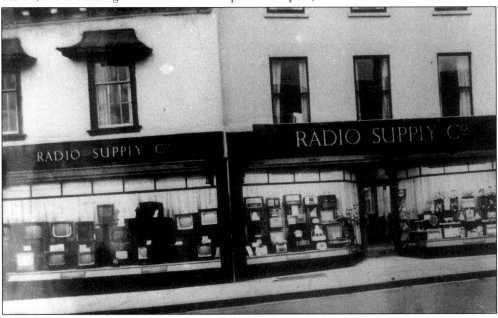

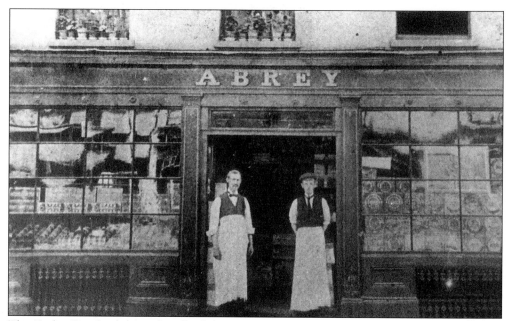

The Radio Supply shop replaced Albrey's grocery with its handsome Georgian shop front, shown here in 1910.

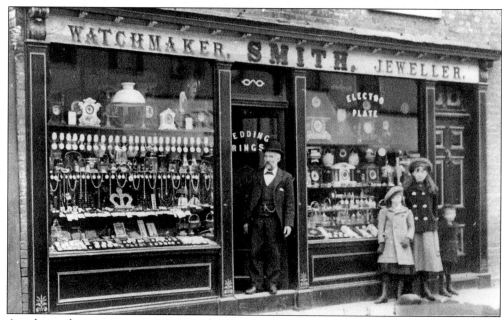

At about the same time, Mr Angelo Smith moved from New Street and opened his watchmaking business and jewellery shop next door. The family is still trading there.

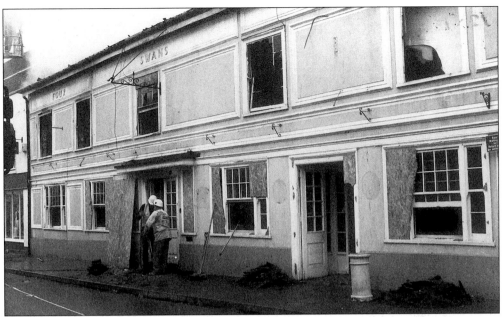

In 1900 Sudbury had thirty-six pubs of which six were in North Street. The Four Swans incorporated the Red Lion some time in the middle of the nineteenth century when it acquired its fine façade. For many years after the destruction of the Rose and Crown it became the foremost inn in the town. In 1997 it suffered the same fate and was gutted by fire. It had already closed and was awaiting re-development as three shops.

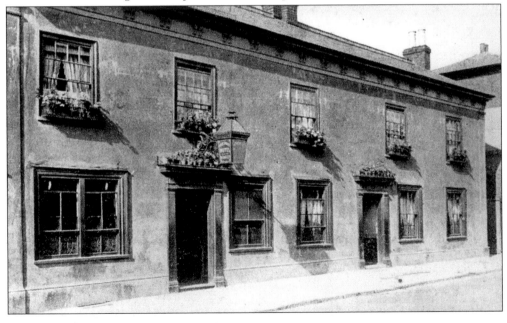

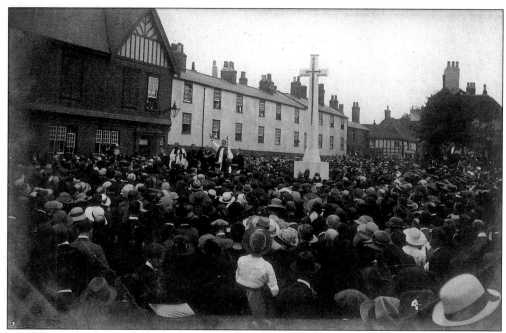

In October 1921 the memorial to those who gave their lives in the First World War was dedicated. It stood at the top of North Street. Behind the memorial can be seen the cottages which formed a courtyard known as The Mount. They were demolished in the 1960s.

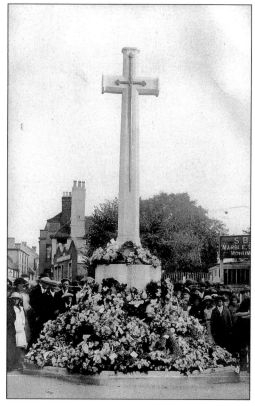

The memorial after the dedication service, decked with wreaths from the families of those whose names are carved on the plinth. Amongst them are the names of the civilians killed in a Zeppelin raid on East Street. The memorial was moved to a new site by St Gregory's church in the early 1970s.

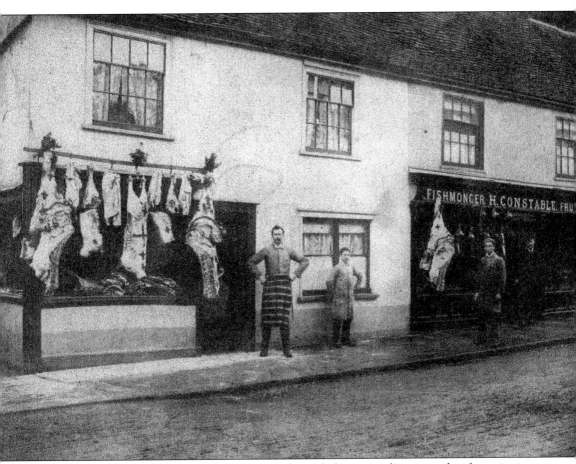

This photograph has only recently come to light and shows another example of continuity throughout the century. The butcher's shop is No. 16 North Street as it was during the latter part of the nineteenth century. Although completely rebuilt a few years later, it remained a butcher's shop and was being run by Mr Bailey during the middle part of the twentieth century. It is still a butcher's shop in 1998. The fishmonger and fruiterer, H. Constable, sold out to Mr Lefley, who carried on trading until the 1960s. Another fishmonger and fruiterer run by Mr King was immediately opposite and both shops coexisted happily for many years.

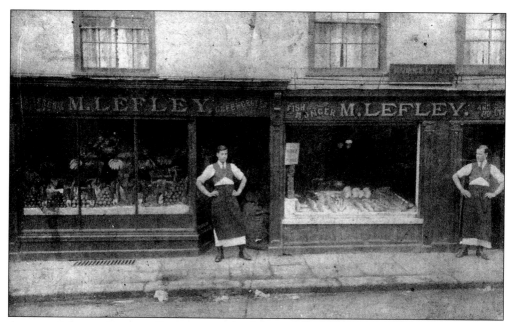

An essential part of any retail service was the delivery of goods to customers. The Lefleys were one of the first in Sudbury to use motorized transport for that purpose. It marked the end of an era during which carriers, using horse-drawn carts operated from the Sudbury pubs, provided a service for outlying villages. Shops began their own delivery services but even these were to be short-lived with the introduction of the country bus.

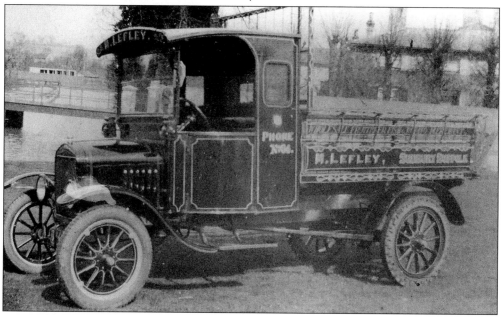

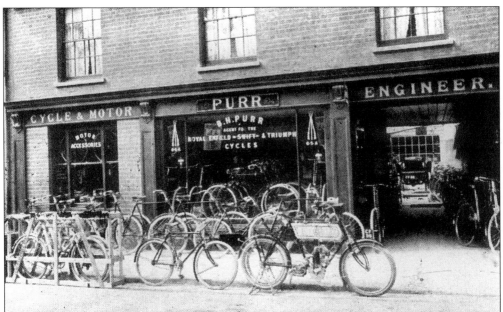

Then, of course, Henry Ford introduced the cheap car. Bertram Purr was Sudbury's main Ford dealer and he also sold cycles and motorcycles. No doubt he serviced the Lefley van. Purr's workshop and showroom was in North Street. The premises later became George Stowe's second hand furniture shop. Every Thursday his advertisement appeared on the front page of the *Suffolk Free Press* with the legend 'This Week's Snip'. Argos now stands on the site.

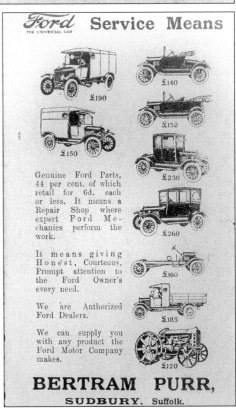

Ford THE UNIVERSAL CAR **Service Means**

£190

£140

£150

£152

£230

Genuine Ford Parts, 44 per cent. of which retail for 6d. each or less. It means a Repair Shop where expert Ford Mechanics perform the work.

£260

It means giving Honest, Courteous, Prompt attention to the Ford Owner's every need.

£160

We are Authorized Ford Dealers.

£185

We can supply you with any product the Ford Motor Company makes.

£120

BERTRAM PURR,
SUDBURY, Suffolk.

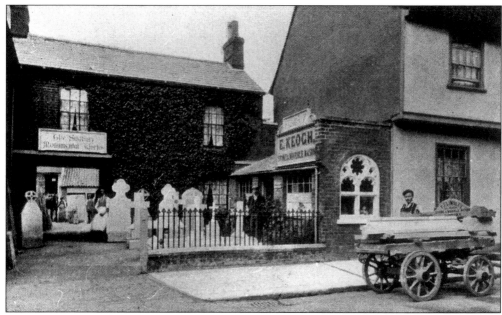

Next door to Bertram Purr's was Keogh, the stone mason. He worked closely with Webb the builder and Grimwood's on Acton Green, both of whom were involved in church restoration. Many of the carved date stones on Grimwood's houses were the work of Keogh. A particularly fine one can be seen in Suffolk Road.

Lion Walk connected the Four Swans yard with Gaol Lane and formed a short cut through to North Street. It had a row of cottages and a corner shop shown here in 1935. It was all swept away in the late 1960s to provide rear-loading access for North Street.

Cavendish Cottages, a very picturesque row of small shops, were demolished in the late 1950s to provide a car park for North Street. Opposite was the Horn Inn with its nineteenth-century façade concealing a much earlier building. Alongside is the Sudbury branch of the Halstead District Co-operative Society.

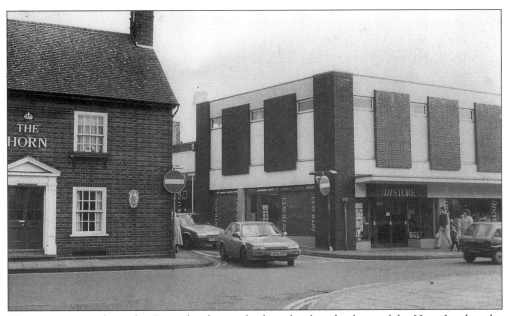

The same view today – the Co-op has been rebuilt and so has the front of the Horn Inn but the timber framed rear still survives. New shops stand on the site of the Cavendish Cottages.

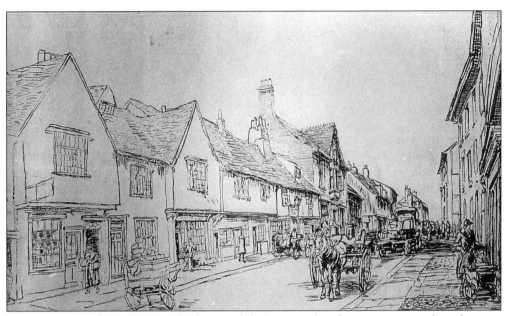

Nobody seems to have photographed Cavendish Cottages, but drawings exist, such as this one, which show us that section of the street in 1924.

The Green Dragon was another medieval pub that was given a new frontage in Edwardian days with glazed green and red bricks which alone should have ensured its survival. It was demolished in the 1960s to make way for an Iceland store.

Numbers 95 and 96 North Street (above), which were at one time the property of the Gainsborough-Dupont family. Shown here in 1910, they were later to become Cutmore's dress shop and bookshop. Next door were Dunkley and Green and Palmer's, both of which were destroyed by fire. The site was acquired by Woolworth's in spite of opposition from local traders. The photograph below shows No. 95 being demolished except for its façade to form an extension to Woolworth's in 1985.

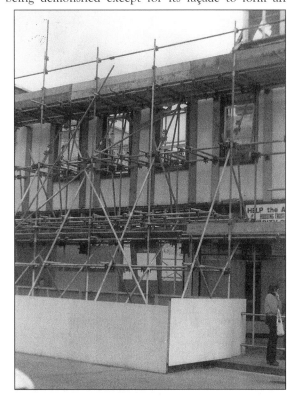

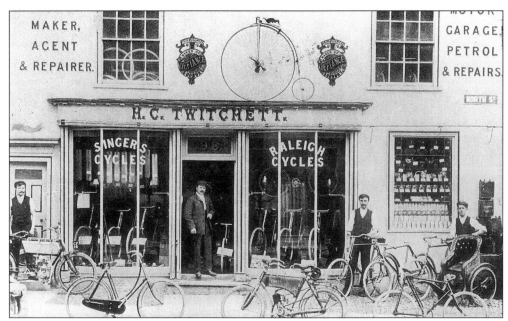

Mr Twitchet's cycle shop was at the very top of North Street by the Old Market Place. It is seen here in 1910, but already he is advertising a 'Motor Garage – Petrol and Repairs'. Cycles were a very popular mode of transport in Edwardian days and the number of shops selling them in Sudbury reflected that. There were at least nine at this time.

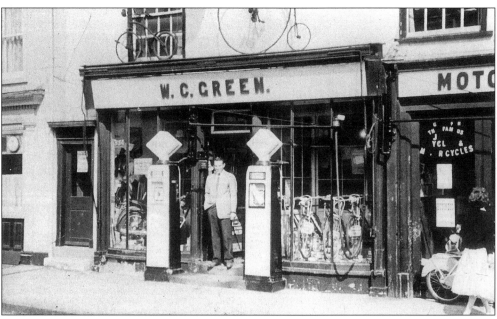

By 1955 the business had changed hands and now petrol pumps are well to the fore. The penny-farthing bicycle is still there but has now acquired a mate.

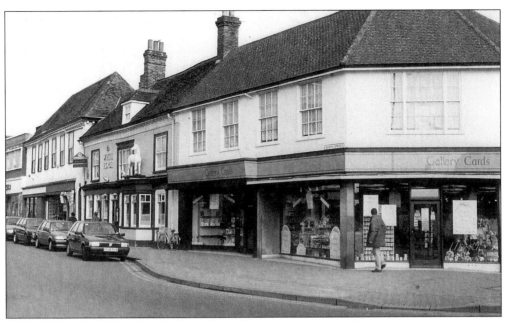

By 1985 Mr Twitchet's shop had disappeared completely. A new building has replaced it and manages to blend in well with its neighbour.

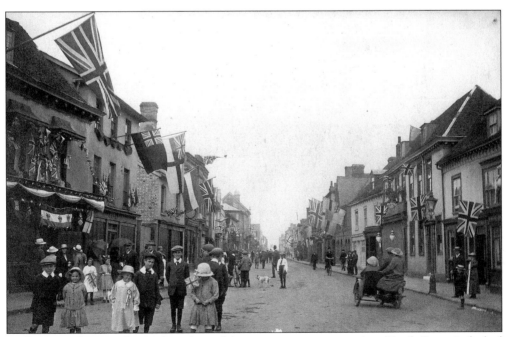

Sudbury people were always pleased to celebrate an important occasion. North Street is decked in flags for the coronation of George V in 1911.

Another example of today's photograph becoming archive material overnight. St Gregory and St Peter's School, founded in 1747, stood on a site backing on North Street. The school was rehoused on a new site and the only surviving feature of the old building is the old entrance arch. In spite of massive opposition from the public and a referendum in favour of retaining the buildings for community use, it was demolished in 1997 to make way for a car park. North Street has now been made 'pedestrian-friendly' and has entered a new phase in its life.

Three
Gainsborough Street to Ballingdon

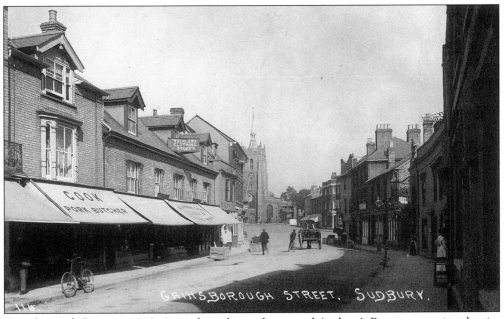

Gainsborough Street in 1912. Apart from the gas lamps and Andrew's Bazaar occupying the site of Midland Bank, this scene has scarcely changed, although the shops have changed hands.

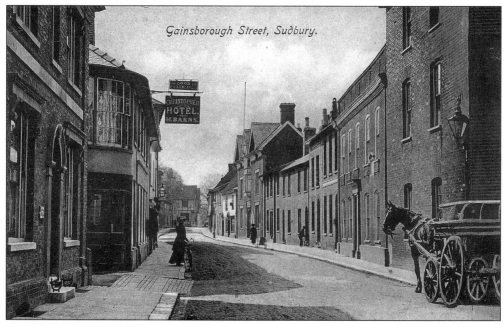

Sepulchre Street was renamed Gainsborough Street around 1910; nobody seems to know exactly when. This photograph shows the street in 1913 and there have been few changes. Gainsborough's house on the far right was then a private dwelling though later it was to become a hotel. The Christopher no longer has doors on the rounded corner and has ceased to be a pub.

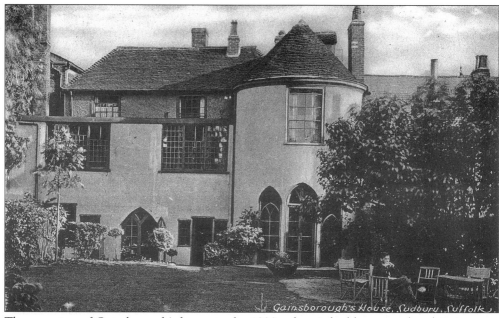

The rear view of Gainsborough's house in the 1930s when it had become a hotel. It is now a museum and gallery with the largest collection of Gainsborough paintings under one roof.

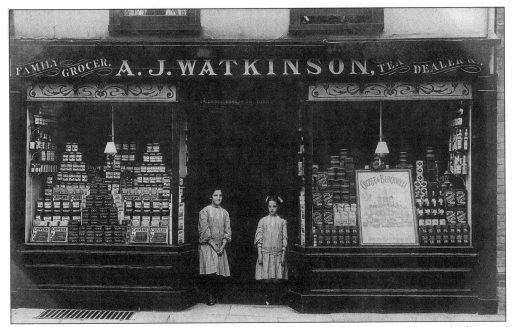

Watkinson's family grocery shop in 1908, with mountains of Chivers jams and tinned salmon in one window and Crosse and Blackwell goods and Quaker oats in the other. Payne Essex, the printers, were trading here in the 1930s but closed in the late 1950s. It is now a hair salon.

Looking back towards the Market Hill. On the extreme right is a three-storey silk mill, which was demolished to make way for Bloys Garage in the late 1950s. It was last used as the local Conservative party headquarters. The garage has also gone and flats now occupy the site.

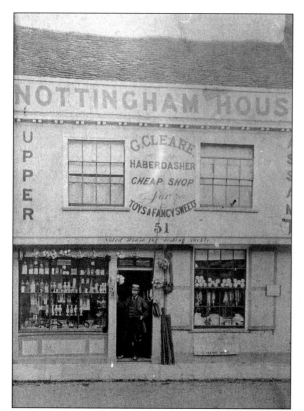

Nottingham House with George Cleare, the proprietor, standing in the doorway, in 1900. His father had been secretary to the Corn Exchange Company when the Exchange was built in 1841. By 1930 the shop was owned by C.D. King, who was a greengrocer and seed merchant. In the 1970s it was a paint shop but it has since become a private house.

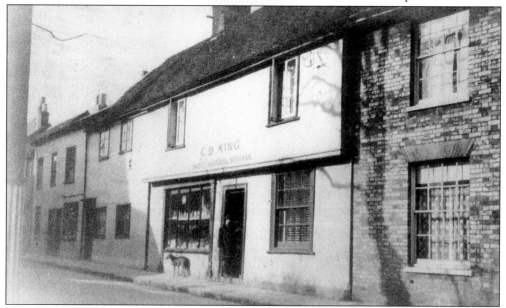

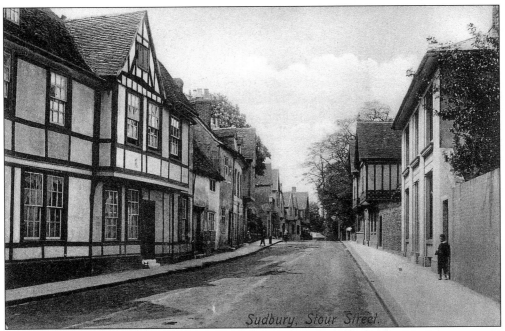

Stour Street in 1910. At this time there was a strange habit of painting false beams on old houses, which made the genuine article look bogus. Here is an example: only the timbers in the gable are genuine; the remainder are painted. The real beams are hidden under the plaster. The house on the right was the home of the Brown family who paid for stained-glass windows and other decorative work in St Peter's church.

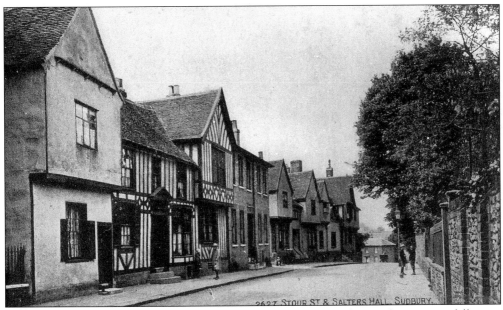

St Mary's in Stour Street is another example of painted beams. They no longer exist following an attack on such work by Basil Oliver, a local architect and author of *Suffolk Cottages and Farmhouses*, which has become a minor classic.

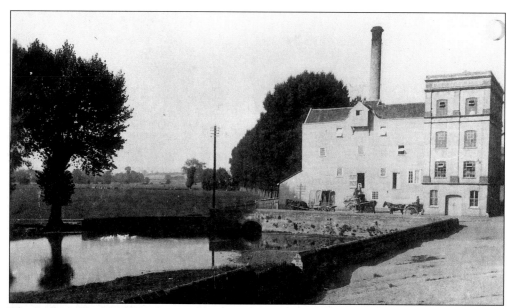

The Sudbury Flour Mills were owned by the Clover family and they are shown here in 1925 just after the Mill House had been demolished. There has been a mill on this site since Saxon times but it ceased functioning in 1964.

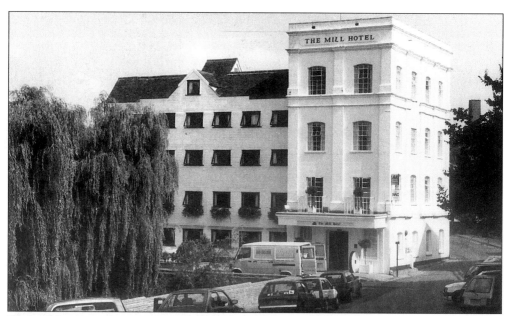

The mill has since been converted into a hotel. During the conversion a mummified cat was discovered and removed. There followed a succession of minor disasters and it was suggested that the cat be returned. It was, and there have been no more problems.

Mr Maskell's little shop in Cross Street served as a tuck shop for the nearby schools until he retired in 1985. The ground floor is below street level as a result of Macadam's work on Mill Hill in the early nineteenth century.

The shop underwent thorough restoration and is now a private house. The Sparrow family owned this property in the early eighteenth century, but it began life as a tannery in the fifteenth century.

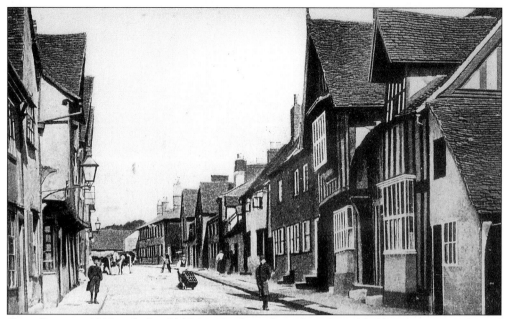

Cross Street in 1900 with the Old Moot Hall on the right. The gabled house opposite formed Playles Yard and was demolished between the wars, leaving an unfortunate gap in this historic street. A garage now stands on the site.

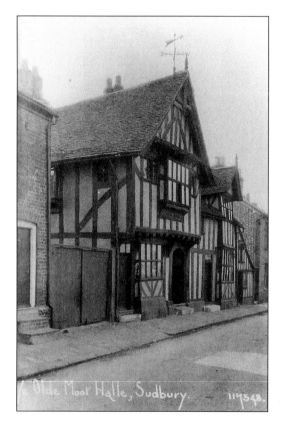

The Old Moot Hall was Sudbury's first Town Hall and part goes back to 1380 at least. Replaced by another on Market Hill (see p. 11) in Mary Tudor's reign, it was still used for civic purposes until the seventeenth century. It has been a private house since restoration in 1945. This photograph was taken in 1939, before the bay windows were removed.

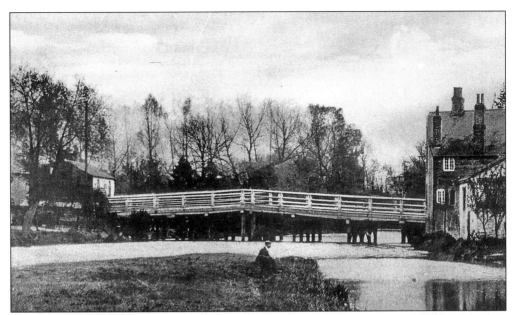

The first Ballingdon Bridge was built for Amica, Countess of Clare, in around 1180. It has been rebuilt many times since then and as the river served as the boundary between Suffolk and Essex there were often disputes as to who was responsible for its upkeep. The problem was finally solved in the nineteenth century when the boundary was moved and Ballingdon became part of Sudbury.

The timber bridge was replaced with the present concrete structure in 1910.

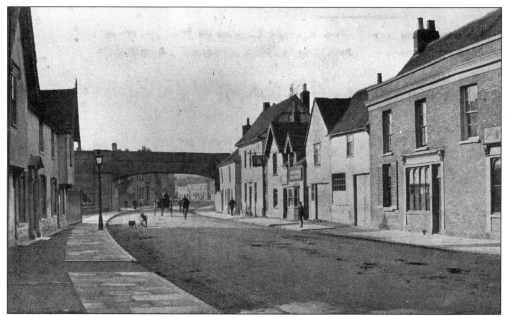

Ballingdon Street was built on the Norman causeway, which crossed the marshes. It is seen here in 1905, with The Railway Bell pub on the right. The gabled building next to it was a stonemason's yard. The railway bridge was erected in 1865 when the line was extended to Cambridge.

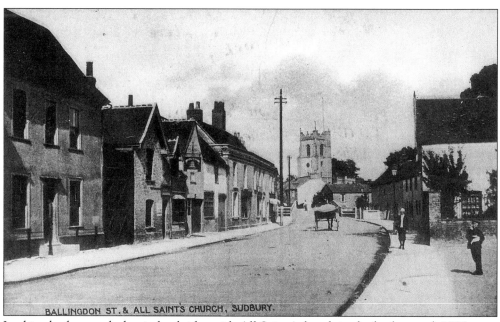

BALLINGDON ST. & ALL SAINTS CHURCH, SUDBURY.

Looking back towards the timber bridge with All Saints' church in the background, 1900.

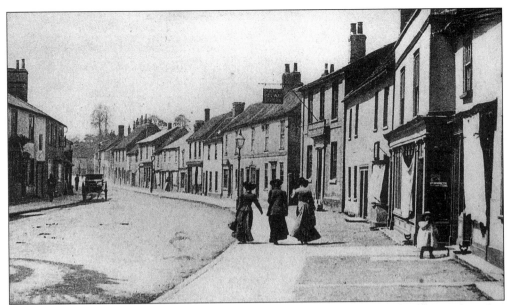

Beyond the railway bridge in 1910. The shop on the right closed a few years afterwards and so did the Railway Tavern, but the buildings remain.

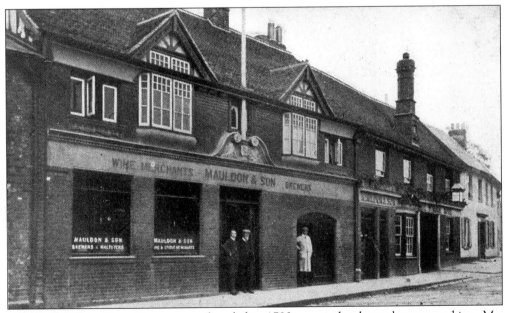

Mauldon's White Horse Brewery was founded in 1793 as a modest home brewery and inn. Mrs Anna Mauldon was innkeeper in 1868. There was a fire in 1900 but the building was soon rebuilt, as this photograph shows. It was taken over by Greene King in 1958 when it owned some twenty-two licensed premises.

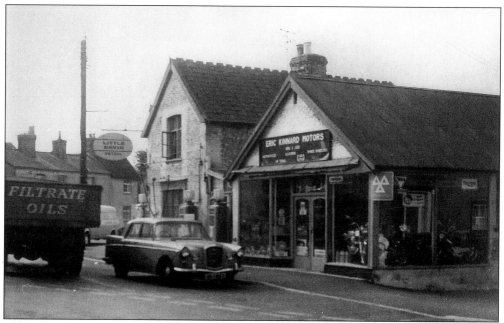

Ballingdon was a busy industrial area in the late nineteenth century, with three brickworks, a coconut-matting factory, silk weaving and a brewery. Pubs were an essential part of the scene and there were six in all. There was also a Mission Hall. All of those industries have long ceased and the mission has closed down but the hall remains. By 1970 (as in this picture) it had become a garage. Now it has a new life as a restaurant.

These attractive old cottages, just round the corner from the Mission Hall, were demolished in 1960 for road widening.

In the eighteenth century Ballingdon was a wealthy street and there are some fine houses which bear witness to the fact. These humble cottages in Bulmer Road tell the other side of the story.

The rear view of the same cottages just before demolition in 1958, showing their outdoor lavatories.

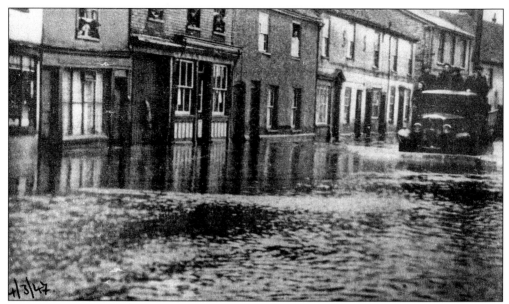

After a severe winter followed by a sudden thaw in 1947, the river Stour burst its banks and Ballingdon was flooded. The situation was aggravated by a floating haystack becoming wedged under the bridge. The houses shown here were flooded to a depth of 2 $\frac{1}{2}$ ft at the height of the flood.

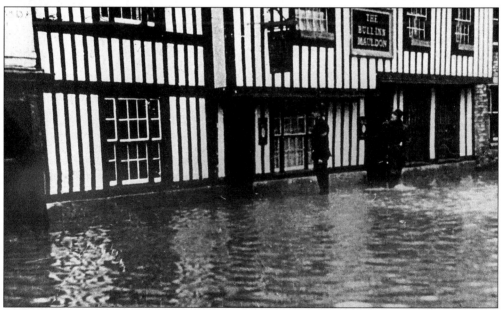

Church Street was also flooded as this photograph of the Bull testifies. So was All Saints' church, where the coffins in the vaults could be heard 'on the move'.

Four
Friars Street to Church Street

Most of the houses in Friars Street had stables backing onto Meadow Lane or Christopher Lane. None have survived. This is the stable at 52 Friars Street as it was in 1939.

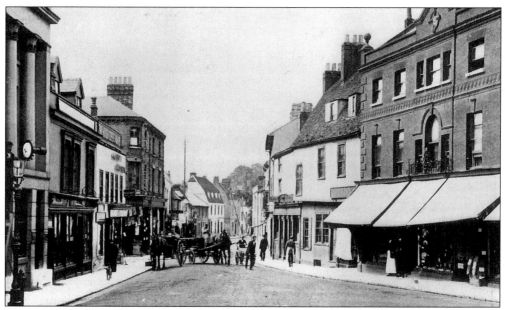

Friar's Street follows the line of the Norman town ditch in one great long curve. There have been few changes since this view of 1910. The shop on the right was Mattingly's gentlemen's outfitters, which only ceased trading in the 1980s. The pub next door will have its frontage altered within a few years.

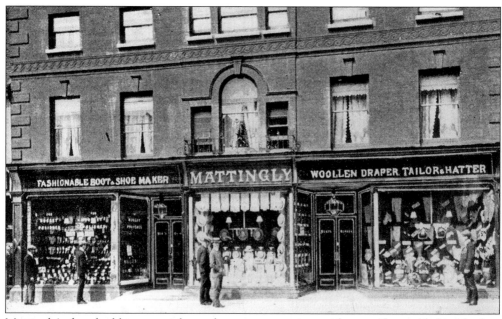

Mattingly's shop had been an eighteenth-century mansion, with a top floor added in the late nineteenth century. The Mattinglys lived in an impressive villa on King's Hill, Great Cornard, called The Chestnuts.

Looking towards the Market Hill in 1912. M. & L. Woolby's Berlin Wool Warehouse is now an antique shop. The next building has painted false beams but the plaster has since been stripped to expose the genuine article – including two hidden windows not visible on this photo. The canted bay window by the cart has been removed and the house has now been converted into shops.

The Friars Street Congregational church was built on the site of the Old Meeting House, which had connections with Gainsborough. It is seen here in 1910. The Manse alongside cost £1,384 to build.

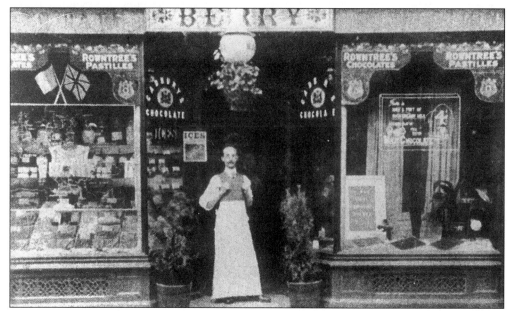

Mr Berry's sweet shop in the 1920s, with the proprietor in the doorway. This was always a high-class confectioners which maintained a display of dummy chocolates throughout the Second World War. It is now a bookshop run by his granddaughter.

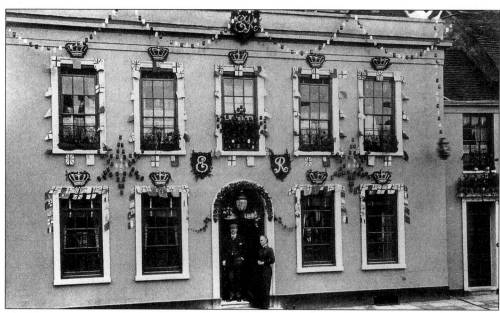

The Friars was a private school in the early 1900s. Here it is tastefully decorated to celebrate the coronation of Edward VII in 1902.

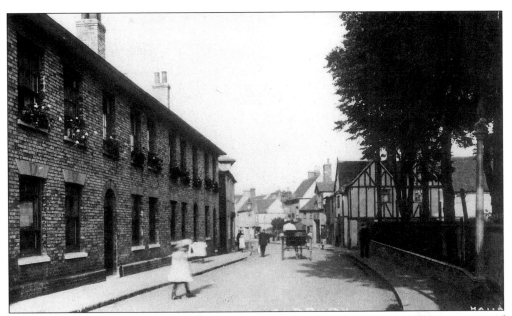

The Limes, opposite the cricket field, was a prep school and kindergarten in 1918. It was one of three private schools in Friars Street at that time. Apart from the removal of the painted beams from the house on the right, this scene has not changed.

These cottages in Church Street were demolished in around 1952 to create extra playground space for the secondary modern school which stood behind them. Subsequent archaeological investigations have shown that they spanned the width of the late Saxon town ditch.

The elegant eighteenth-century shop front has now been restored after becoming somewhat dilapidated. In the 1920s and for thirty years thereafter, it was White's bakery. It later became a grocer's shop and the unofficial tuck shop for nearby schools.

The Red House in Bullocks Lane is one of the town's most elegant Georgian houses. It was occupied by the army during the Second World War and left in a damaged state. It was saved from demolition in 1947 and became a home for 'retired gentlefolk'. This photograph was taken soon after it opened.

Five

King Street and Station Road

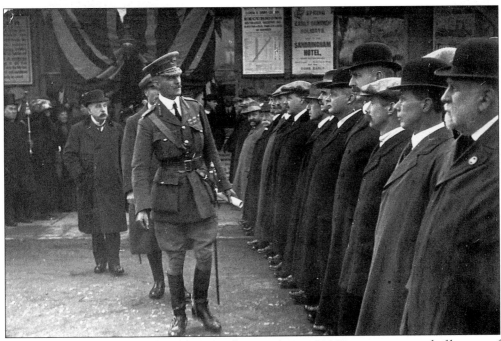

Major-General Barnardiston arriving at Sudbury station in 1914 to inspect a guard of honour of Boer War veterans.

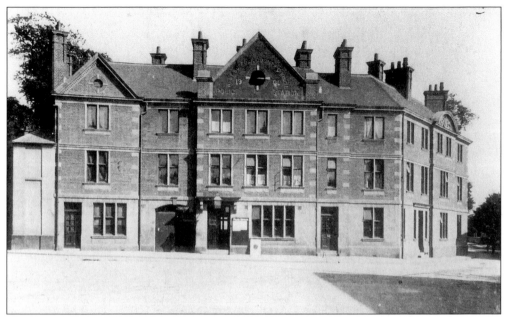

The first Sudbury police station was situated behind the Town Hall in cramped conditions. In 1901 a fine new station was built at the foot of King Street, closing in the view from Old Market Place. The building included accommodation for police officers. In 1967 it was replaced by a new building in Acton Lane and subsequently pulled down. The site is now occupied by a flowerbed and a traffic roundabout.

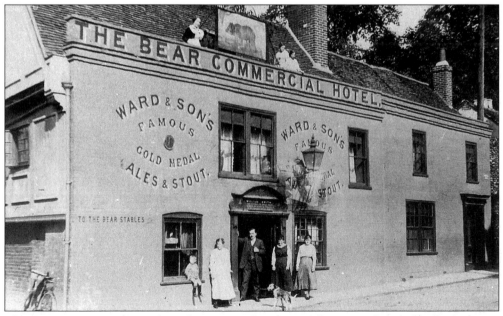

The Bear Commercial Hotel in the 1920s when Mr William Smith was landlord. It was threatened with demolition for a proposed ring road in 1967 but public opinion backed its conservation. The road was re-aligned and the pub was saved.

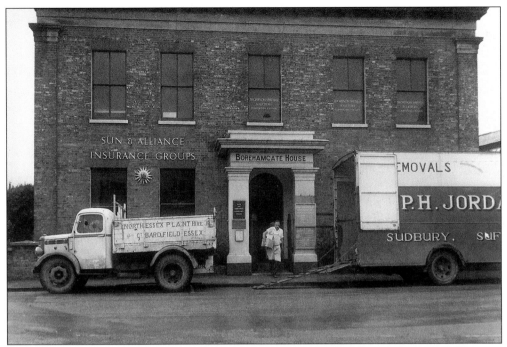

Borehamgate is a corruption of the 'bar and gate' which marked the entrance into the town from Colchester and Ipswich. Borehamgate House was a Victorian mansion standing on the site of its seventeenth-century predecessor. Here it is about to be demolished to make way for a shopping precinct in 1965. Wheeler's timber yard, to the right in King Street, disappeared at the same time.

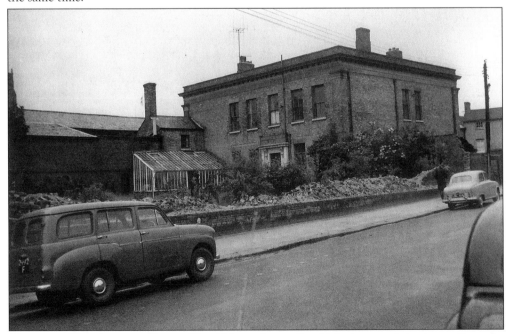

The rear of Borehamgate House. The 10ft garden wall, which protected the house from the public gaze, went in 1965 and a week later not a brick remained of the mansion.

The aftermath. Borehamgate Precinct has been built and a road island replaces the police station. Since 1971, when this picture was taken, the island has been enlarged and the traffic

now flows one way. The precinct has been revamped and still nothing has been built to close in this street view.

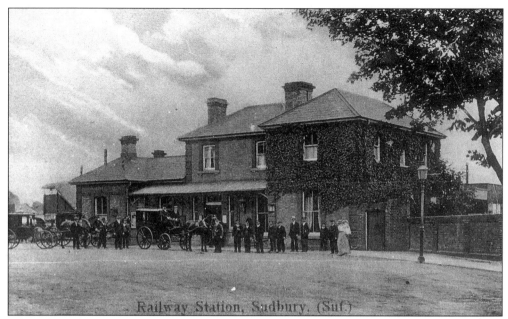

Railway Station, Sudbury. (Suf.)

When the railway arrived in Sudbury in 1849 the station was at the top of Great Eastern Road by Cornard Road. A new station was built when the line was extended to Cambridge in 1865 and it was approached by an avenue of lime trees.

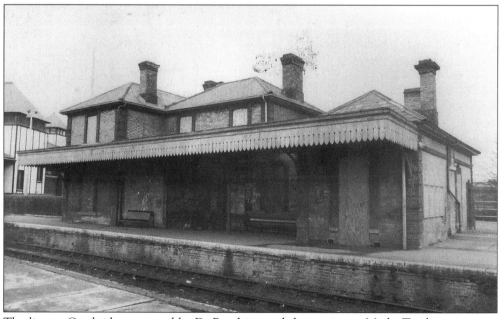

The line to Cambridge was axed by Dr Beeching and the service to Marks Tey became a pay train so there was no further use for a station as such.

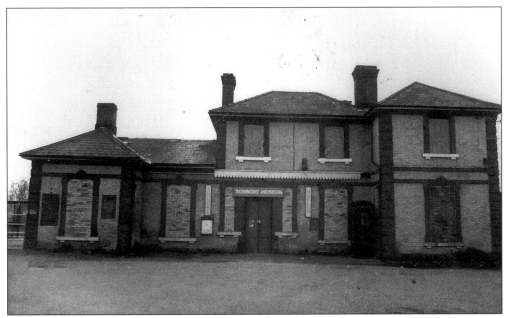

For a time the station premises were used by the Sudbury Museum Trust, only to be set on fire by an intruder. The building was finally demolished to make extra car parking for the new station halt.

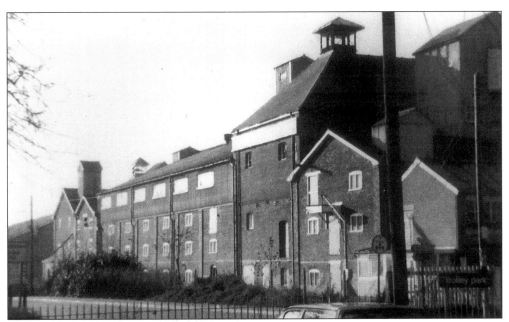

Close by the station were the nineteenth-century EDME maltings. This was a splendid industrial building which was on the verge of being listed but the demolition men moved in fast. Somerfields supermarket and car park fills the site.

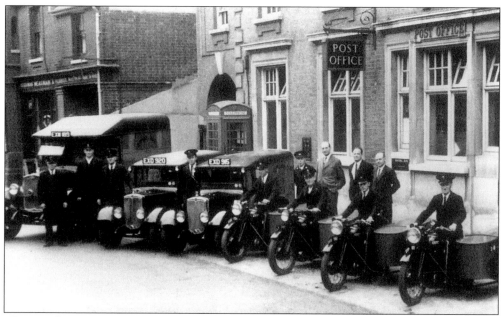

The proud motorized postmen outside the old post office in Station Road, 1938. From left to right: Postmen George Cutmore, Maurice Silitoe, Ben Radley, Ron Chaplin, Bert Hines, Les Carter, John Brown. At rear: H. Burts (Head Postman), Mr Carter (Head Postmaster), Mr Skitmore (Overseer) and Bertie Nicker (Secretary).

The buildings adjoining the post office formed part of the Salvation Army Citadel. They were taken down in 1998. The shops were Orbell tea rooms, run by Mr and Mrs Gates in the 1940s. In the late fifties it became the Bongo coffee bar, one of three in Sudbury when such places were the rage. The others were the Zanzibar and the Bambi in Gainsborough Street and North Street respectively.

Six

Special Events

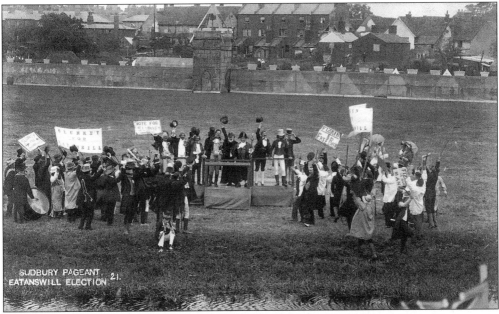

The Sudbury King George V Coronation Pageant, held on the Freeman's Great Common in 1911. The re-enactment of the Eatanswill election from *Pickwick Papers* is being staged here. Dickens was sent to Sudbury to report on a notorious by-election which he vividly describes in his novel. Sudbury is thinly disguised as Eatanswill – 'the rottenest of Rotten Boroughs'.

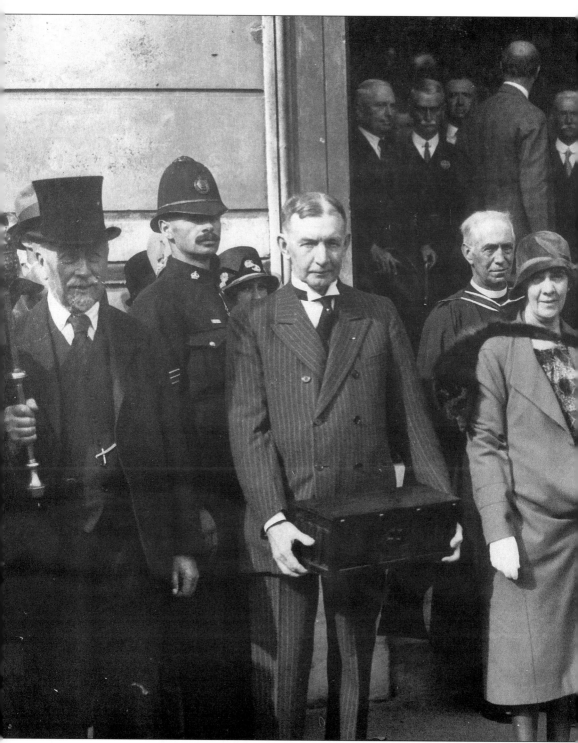

On 1 October 1929 General Charles Gates Dawes, US Ambassador, was given the Honorary
Freedom of the Borough of Sudbury in commemoration of his ancestral connection with the
Borough through William Dawes, who sailed to America in 1635. General Dawes holds his

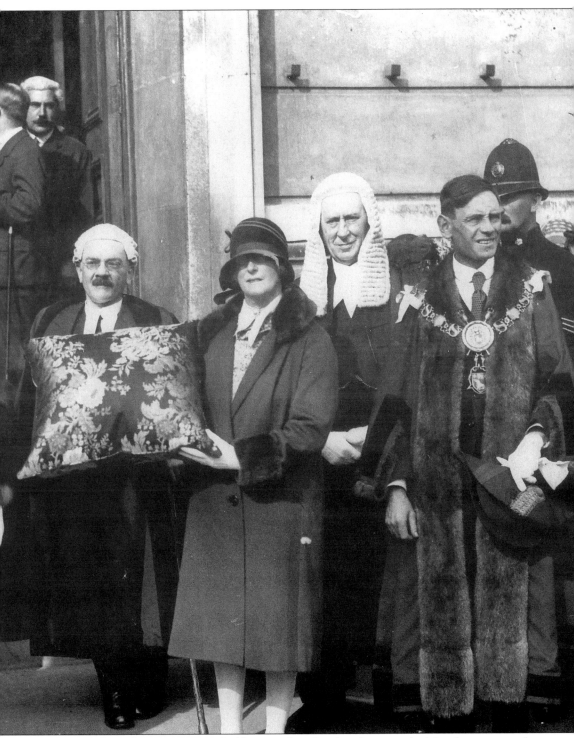

Freedom Casket while Mrs Dawes holds an embroidered cushion worked by the women of Sudbury.

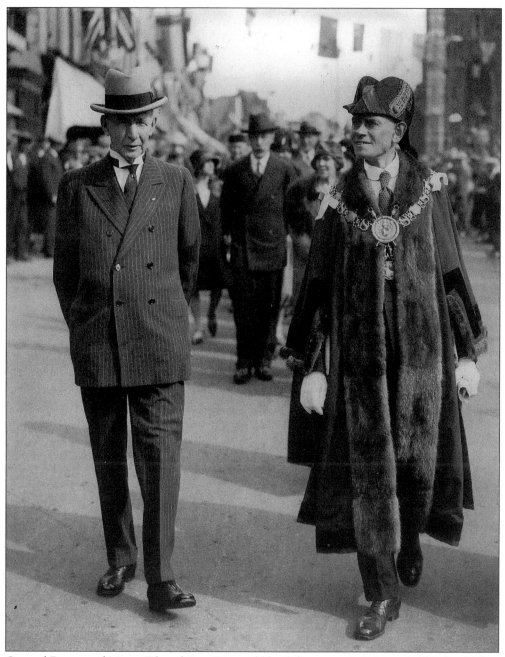

General Dawes and Mayor Edward Page Fitzgerald lead the procession down the Market Hill to Gainsborough's House for a reception.

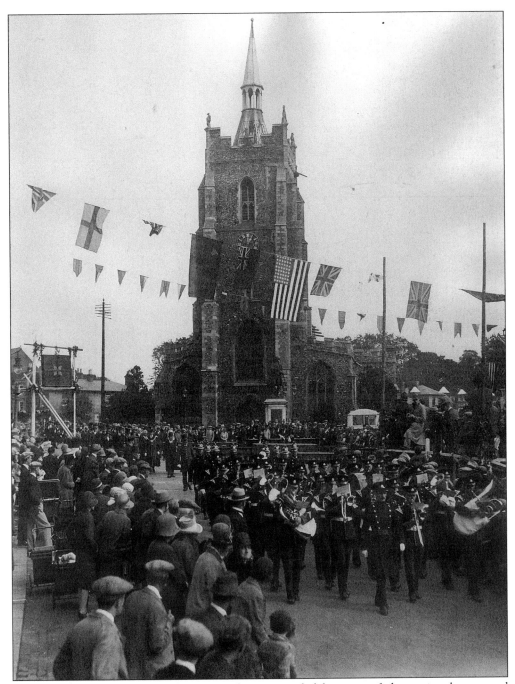

This was treated as a national event and was attended by most of the national press and reported widely the next day. On such an occasion the Market Hill comes into its own. Sudbury people flocked to the Gainsborough cinema to see it all on the silver screen via the newsreel the next week.

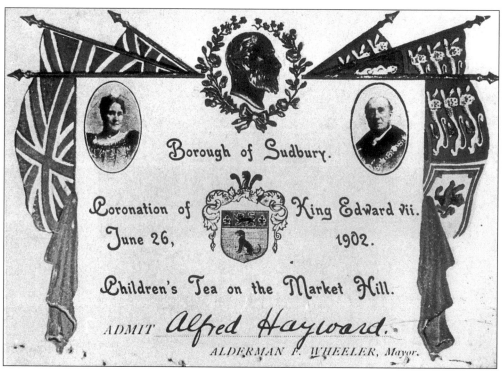

Borough of Sudbury.

Coronation of King Edward VII.
June 26, 1902.

Children's Tea on the Market Hill.

ADMIT *Alfred Hayward*.

ALDERMAN F. WHEELER, Mayor.

A giant party was held for all the children of Sudbury to celebrate the coronation of Edward VII on 26 June 1902.

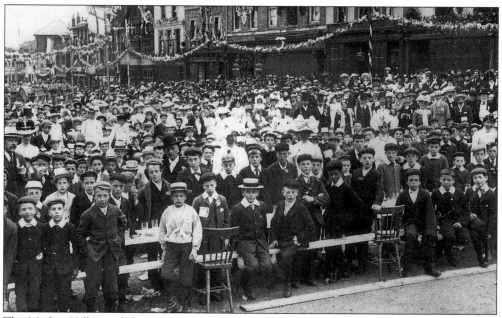

The Market Hill suited the occasion admirably. It had become more or less an unofficial civic square.

On 20 May 1910 the Hill became the setting for the ceremonies marking the funeral of Edward VII.

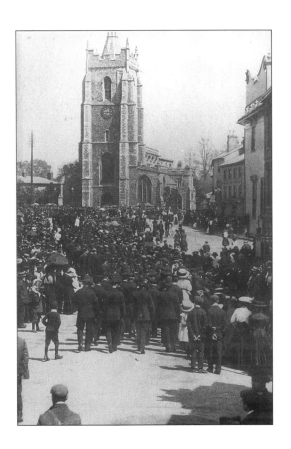

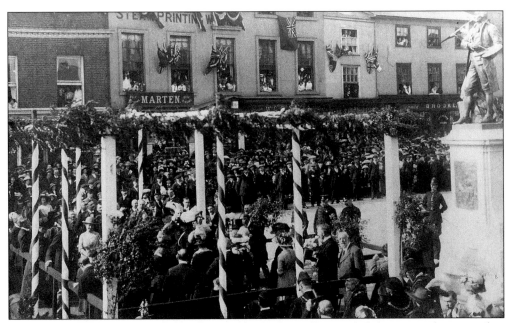

On 10 June 1913 HRH Princess Louise, Duchess of Argyll, unveiled the national memorial to Thomas Gainsborough in the form if a statue of the painter by Bertram Mackennal.

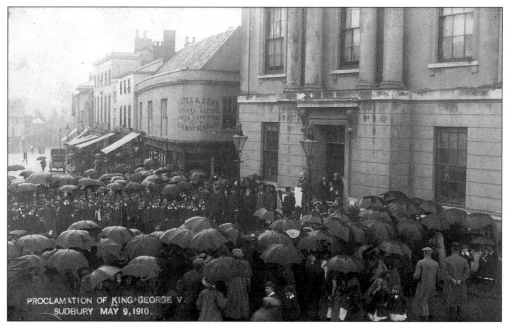

George V was proclaimed King outside the Town Hall on 9 May 1910.

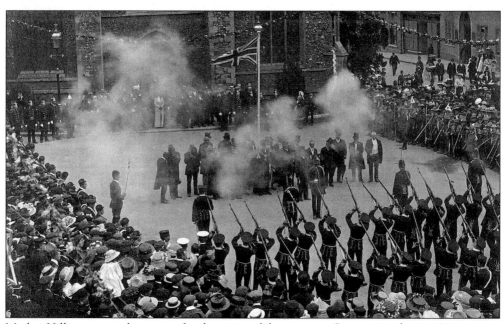

Market Hill was again the setting for the civic celebrations on Coronation day in 1911.

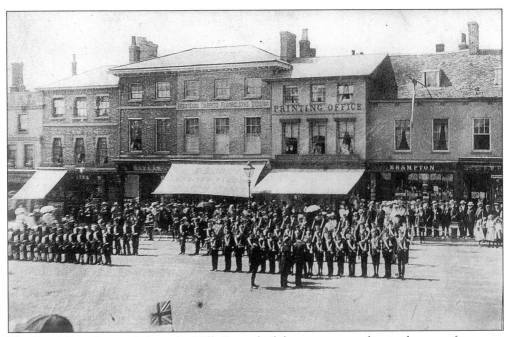

The Boys' Brigade paraded on the Hill. Several of them were to enlist in the army four years later to fight for their country. Sadly some of those did not return from the war and their names would be carved on the War Memorial with sadness and pride.

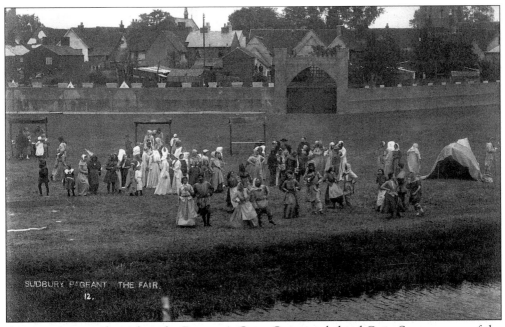

A pageant was performed on the Freeman's Great Common behind Cross Street as part of the celebrations.

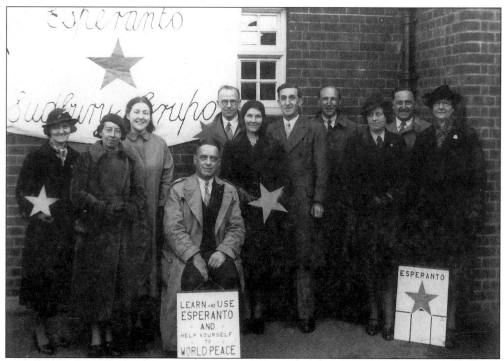

In April 1939, a Sudbury Esperanto Group was formed in the hope that it would contribute to world peace. Among those present are: Hilda Bettridge (second from the left), Francis Dean (seated), Vincent Bettridge (behind him), Mrs Eason (far right) and Clive Sawyer (second from the right).

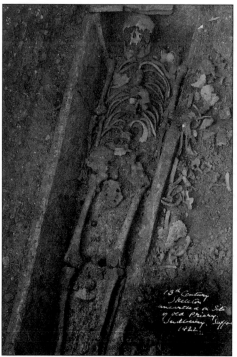

In 1922 a skeleton in a stone coffin was uncovered in Kemp's haulage depot in Friars Street. The discovery led to the identification of the site of the Priory church, which was demolished by Thomas Eden in 1540.

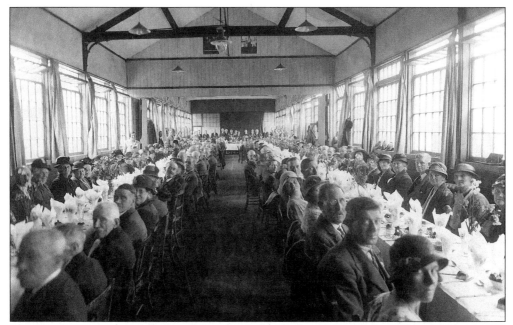

In 1935 there were nationwide celebrations to mark the Silver Jubilee of King George V. In Sudbury there was a party for the council staff and the elderly. What is particularly interesting about this picture is the venue. The party is being held in St Gregory and St Peter's parish hall, which was a converted silk factory – hence the long range of windows, which had provided ample daylight for the looms. The building has had a chequered history since then and had become quite dilapidated by 1998. It is about to be restored and will once again enhance Acton Green and North Street car park.

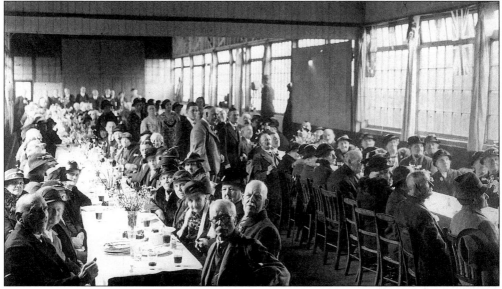

National events gathered momentum. By 1937, since the last photograph, the king had died, another had abdicated and a third had been crowned, all in the space of two years. The luncheon is repeated at the same venue but only close study will show that these pictures are of two different occasions.

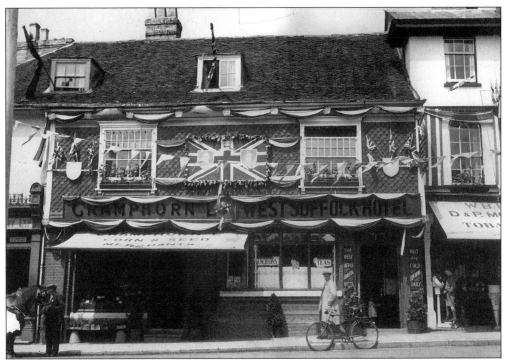

The West Suffolk Hotel was run by Connie Prigg, who was born at the Black Boy, a few doors away. Market day lunches attended by local farmers were held here, at which they all sat round one great table. Here the hotel is decorated for the 1937 coronation.

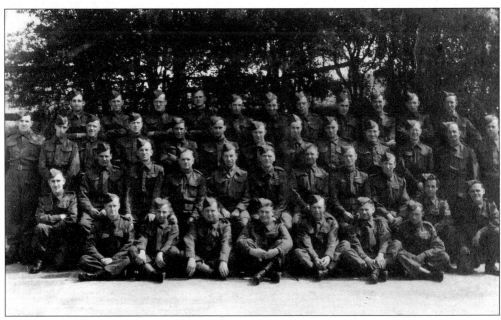

Two years later the country was at war with Germany and, like every town, Sudbury had its own Home Guard.

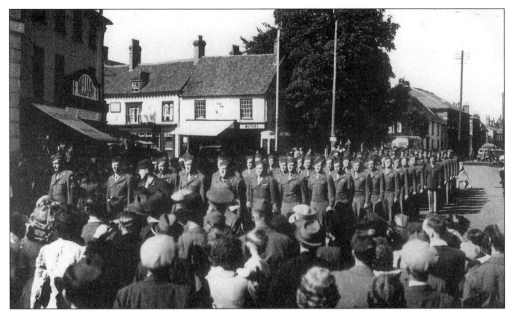

The United States Air Force 486 Bombardment Group (H) was based at Acton. From there they flew 191 combat missions over Germany and Nazi-held Europe from May 1944 to July 1945. Before they left Sudbury, a plaque was unveiled at the Town Hall commemorating their stay and thanking the people of Sudbury for their hospitality.

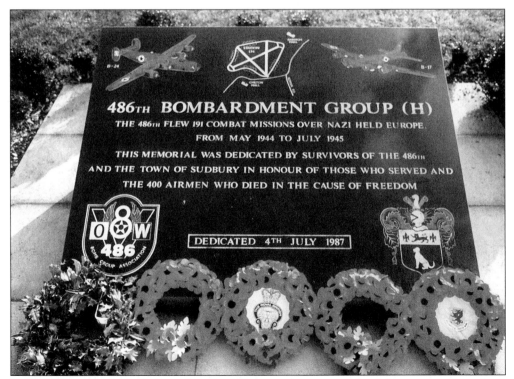

In 1987 a memorial was dedicated to the 400 young Americans who did not return from those missions.

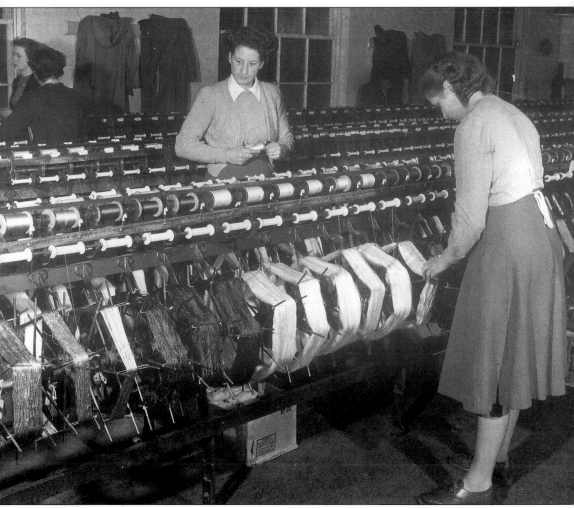

The silk-weaving industry came to Sudbury from Spitalfields in London towards the end of the eighteenth century. Sudbury is now the largest producer of woven silk in Europe. In 1953 Stephen Walters had the honour of making the lining for the Queen's coronation robes. Betty Kilby is seen winding the pure natural silk on to bobbins after it had been thrown and dyed cream in the skein for making the warp.

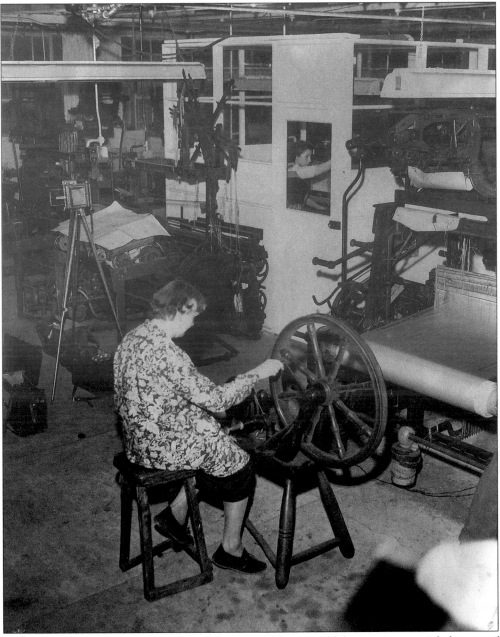

Seventeen-year-old Gwen Curtis working on a fifty-year-old loom in a special dust-proof enclosure, weaving the silk lining for the Coronation robes. Forewoman Ivy Noon is in the foreground.

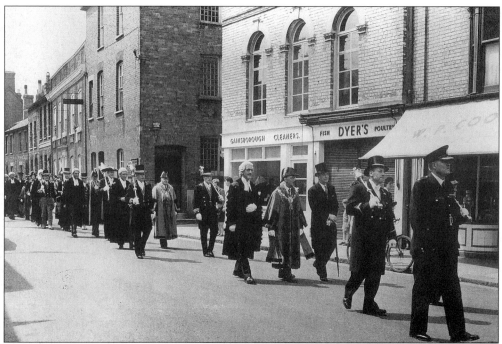

In 1954 Sudbury celebrated the grant of the first Royal Charter from Queen Mary in 1554. The Mayor, Councillor H. Talbot, and Mr Coates, the Town Clerk, lead the procession from the civic service to the Town Hall.

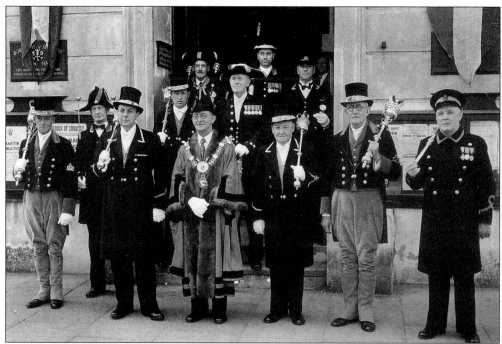

Civic dignitaries from Sudbury, including the town's long serving Mace Bearer, Mr Cresswell, standing right of the Mayor. Mayors from other towns also pose outside the Town Hall with their Mace Bearers.

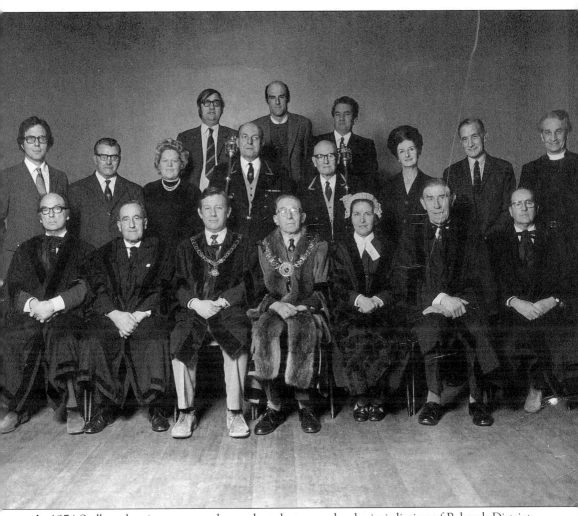

In 1974 Sudbury lost its status as a borough and came under the jurisdiction of Babergh District Council. This photograph shows the last members to serve on the Sudbury Borough Council. From left to right, standing at the back: Mr Taylor, Paul Norman, R. Moulton. Centre: A. Moore, P. Moulton, Valerie Moulton, Mr Chinnery and Mr Cresswell (mace bearers), Mrs Playford, Mr Barker, Peter Hollis (chaplain). Front row: Aldermen Playford, Essex, McQuhae, Mr Banham (the Mayor), Doris Clark (Town Clerk), Aldermen Burn and Moulton.

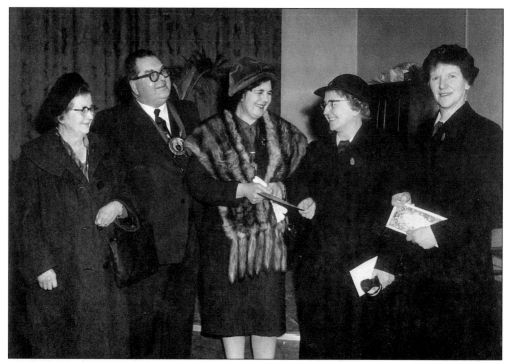

District Nurses Richardson (far right) and Greenwood retired in 1962 after twenty-seven years' service. Here they are being presented with cheques from the Mayor and Mayoress, Councillor Geoff Kisby and Mrs Kisby. On the far left is Mrs C.H. Hitchcock, president of the West Sussex Nursing Association and one-time Mayor of Sudbury.

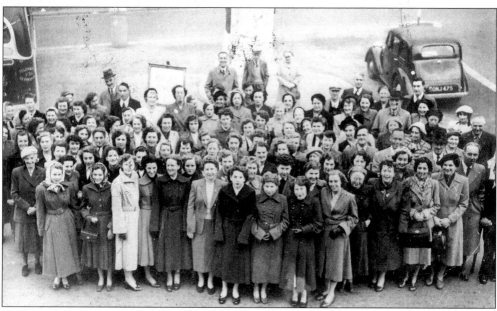

Staff outings were very popular, especially at a time when few people owned cars. In 1947 the ladies from Redell's corset factory pose for a group photograph before setting off.

Seven
Leisure and Pastimes

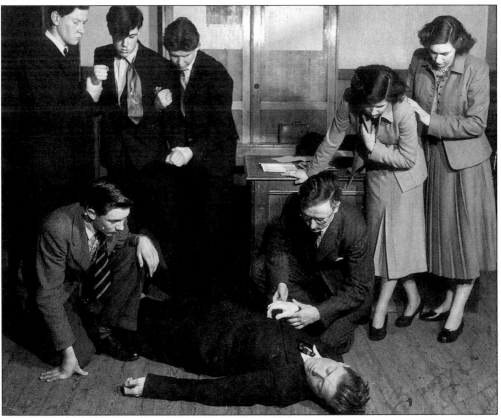

There was a successful and popular youth club at Hardwick House. In 1949 the drama section performed *Easy Money* at the Grammar School hall. From left to right, standing: Barry Wall, Kenneth Allen, Neil Swindles, Anne Conroy, Barbara Turner. Kneeling: Charles Smith, John Bareham. The identity of the 'body' is unknown. Members of the drama section often moved on to the Sudbury Dramatic Society after leaving the youth club.

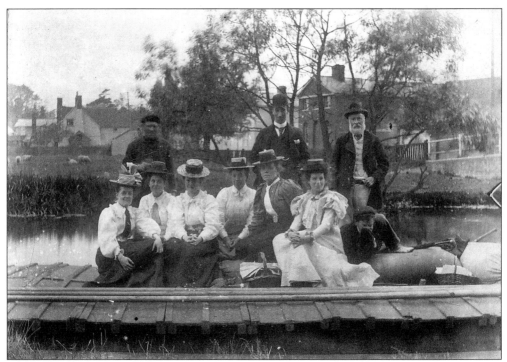

The commercial barge traffic was in rapid decline following the arrival of the railway. Some barge owners took advantage of the Edwardians' passion for boating and began barge trips along the Stour. May and Kate Ling (second and third from the left) have joined a party on a trip from the quay to Bures.

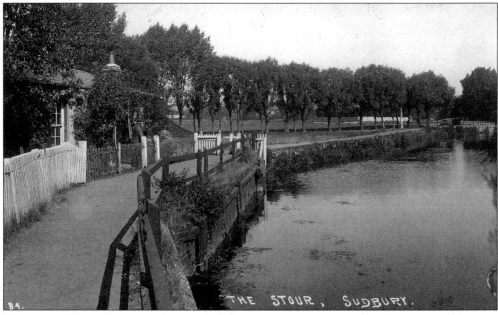

Those who did not boat took advantage of the many pleasant riverside walks, one of which was along the floodgates path through the common land. The cottage on the left housed the keeper of the floodgates who was employed by Clover's Mill. It has long since gone.

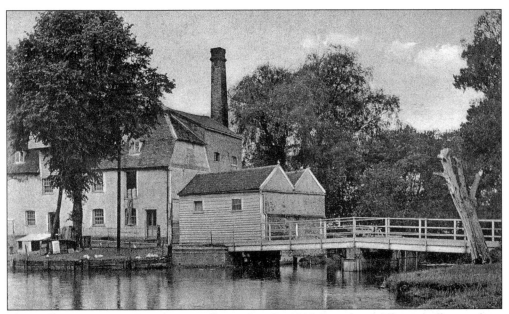

The walk upstream to Brundon is still popular. In 1910 Brundon Mill was still a working flourmill. Now it is a delightful residence in one of the most attractive corners of Sudbury.

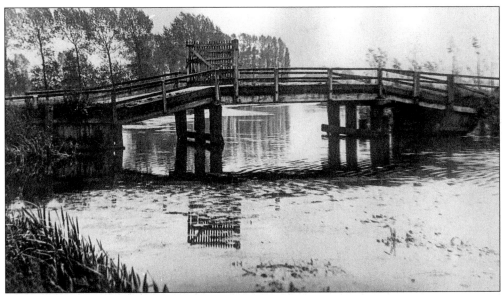

Ladies Bridge crossed to an island off the Cornard Road. To the left was a cutting, which served as a quay for loading barges with lime and bricks from the Ingram's Well pit. It was replaced by a railway siding but neither exists today. The island too has gone – and of course the bridge.

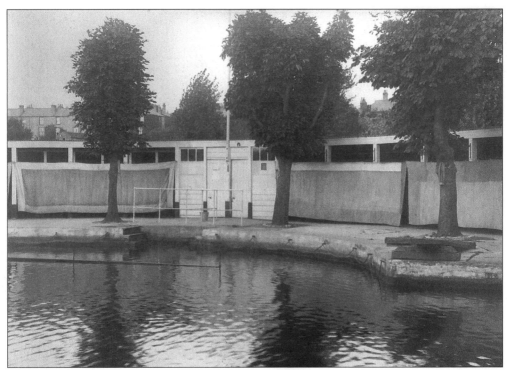

Between the wars there was much emphasis on physical fitness, especially during the 1920s. The river Stour is not really conducive to safe bathing, but a section upstream from the floodgates was set aside for public use. It was extremely popular and safe, provided one kept within the bounds and avoided the swift current towards the floodgates.

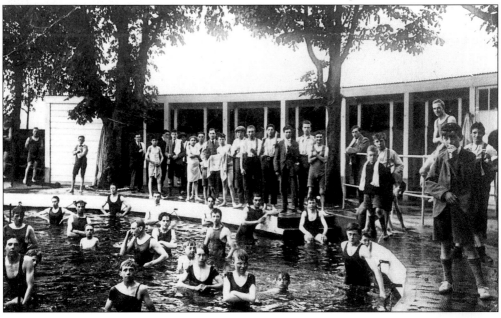

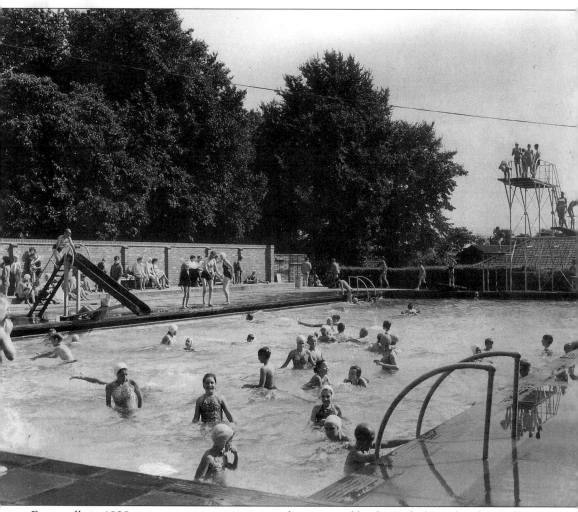

Eventually in 1939 a new open-air swimming pool was opened by the Earl of Cranbrook at Belle Vue, just behind the police station. It was always popular; this photograph is dated 1959. It has since been replaced by the Kingfisher pool in Station Road. The site of this pool is now a council storage depot.

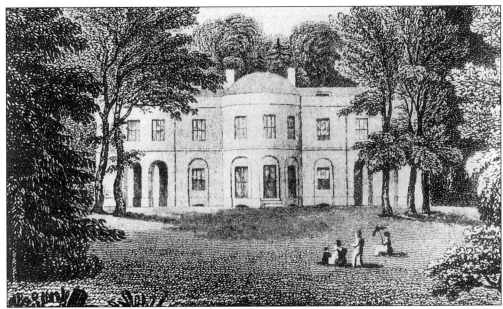

Belle Vue was originally built in the 1780s by Nathaniel Burrough, a retired grocer related to the Gainsboroughs. This engraving is from a painting by Richard Gainsborough Dupont, a great nephew of Thomas Gainsborough, the painter.

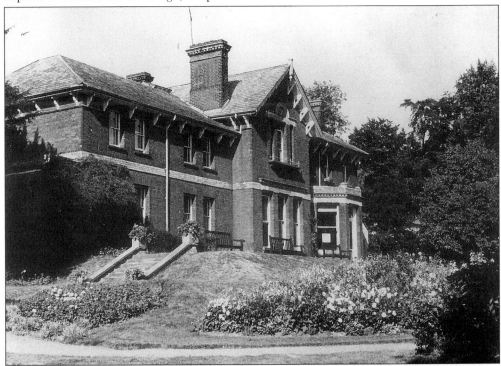

The house was rebuilt in the nineteenth century and after the First World War became the Borough council offices. The gardens, together with those of Ingram's Well, form a town centre park. The future of the house is now uncertain following the removal of the offices to the Town Hall.

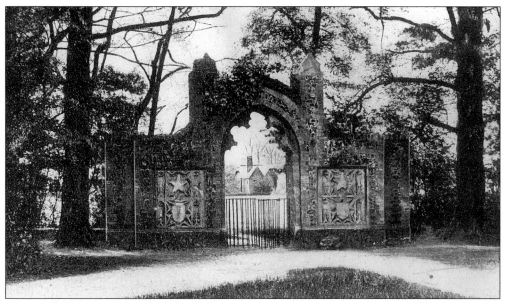

On the outskirts of the town at Middleton the Revd St Clere Raymond created a very pleasant park on his glebeland with avenues and terraces. In the midst was this arch built from stones removed during the restoration of Lavenham church by Penrose. It commemorates the birth of Victoria's eldest son, the Prince of Wales (later Edward VII). It was a popular venue for country walkers when this picture was taken in 1910.

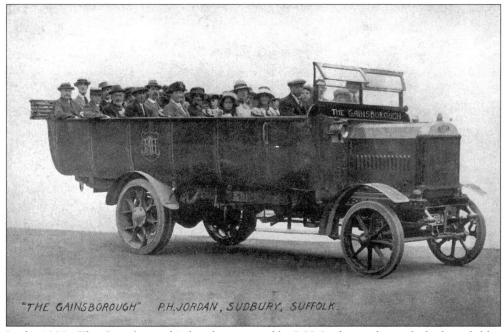

In the 1920s 'The Gainsborough' charabanc owned by P.H. Jordan took people further afield.

Sudbury Football Club was founded in 1885 and played at Belle Vue. The earliest photograph we have at present is of the Reserve Team in 1906/07. Unfortunately, we have no names to put to the faces.

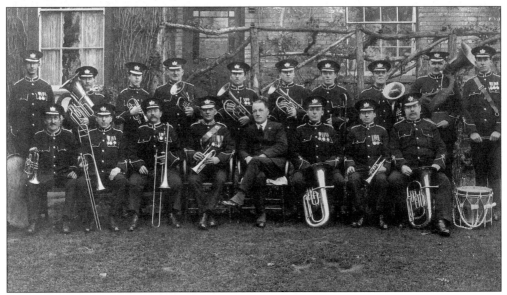

If you had musical talent in the days before pop groups you may well have joined the Town Band. They were much in demand for processions, fêtes, and concerts. Pictured here is Sudbury Town Band in 1923 with their president, G.H. Openshaw. Left of him is Bandmaster J. Pearson DCM and to the right is the Deputy Bandmaster, A. Hartley.

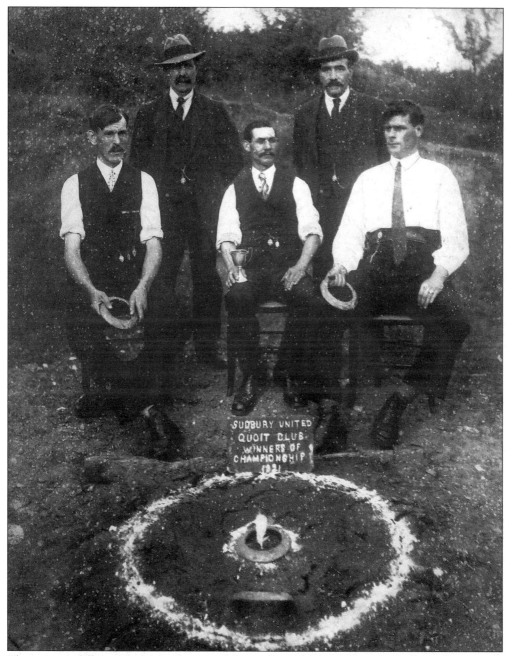

There was a full complement of sports clubs in the 1920s including football, cricket, tennis, bowls, rowing and, as can be seen here, quoits. The Sudbury United Quoit Club were winners of the championship in 1921.

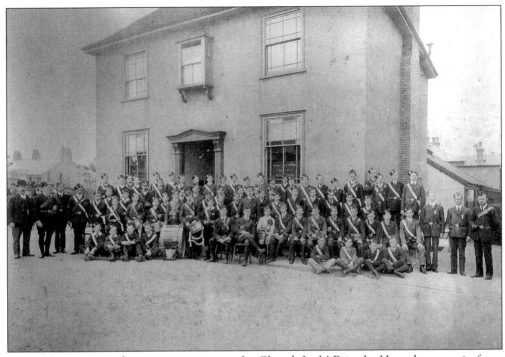

One of the most popular groups to join was the Church Lads' Brigade. Here they pose in front of a house in Queen's Road in 1907.

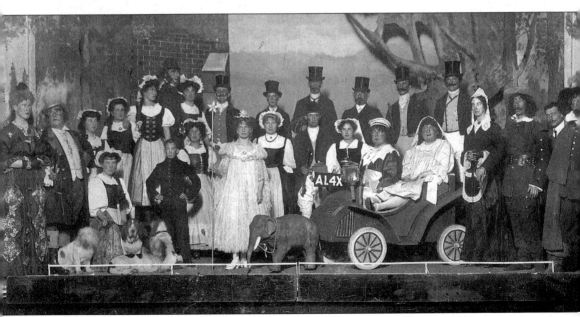

Sudbury Dramatic Society has been in existence since Victorian days. In 1912 they ventured into pantomime with a production of *Cinderella* at the Victoria Hall.

Eight

Transport

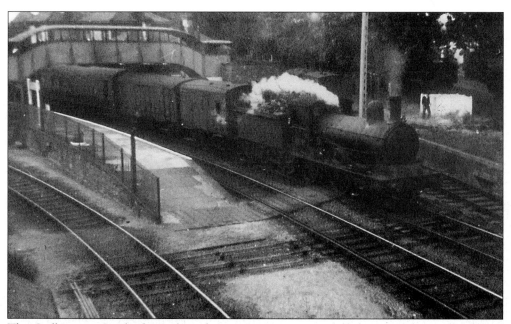

The Sudbury to Cambridge railway line was an important link between the Midlands and Harwich, especially during the war. It came as a bitter blow when the line was axed by Dr Beeching. Here one of the last goods trains leaves Sudbury station in the 1960s.

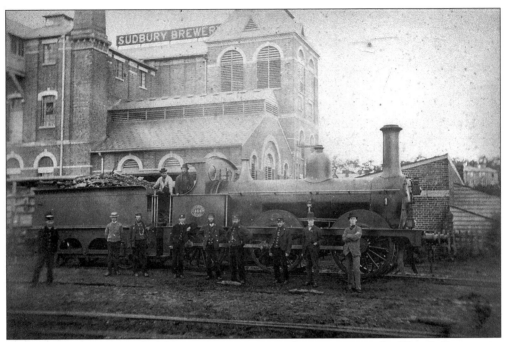

A steam locomotive marked 'Great Eastern 444' with its crew outside Oliver's Brewery in Cornard Road, possibly in 1890. The brewery was operating in 1874 and was taken over by Greene King in 1919. It was closed in 1932 and the site was acquired by the Arlington Motor Company.

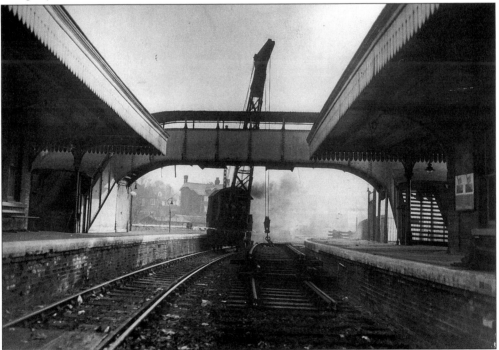

Sudbury station after the axing of the Cambridge line by Dr Beeching. The track is being lifted by railway crane. The footbridge was dismantled and taken to Chapel Rail Museum.

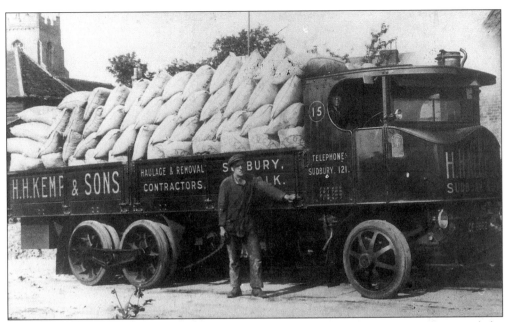

H.H. Kemp & Sons ran a road haulage business from Priory Walk in Friars Street until the 1950s when it was nationalized and became part of British Road Transport. Here a proud driver poses with his loaded steam lorry in around 1920.

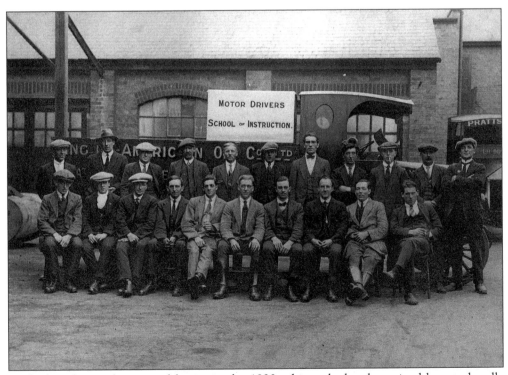

With the advent of motorized lorries in the 1920s, drivers had to be trained how to handle them. Where better than a Motor Drivers School of Instruction?

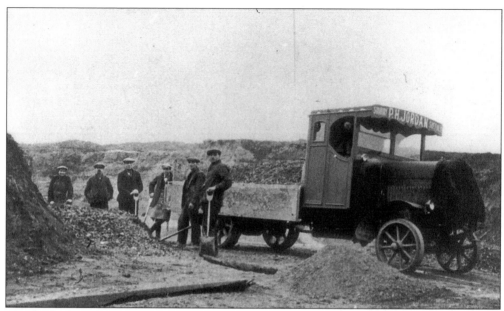

P.H. Jordan had chalk and gravel pits in Sudbury and Brundon. They also had a house removals service. The work at Brundon pit exposed fascinating and important information for geologists and archaeologists.

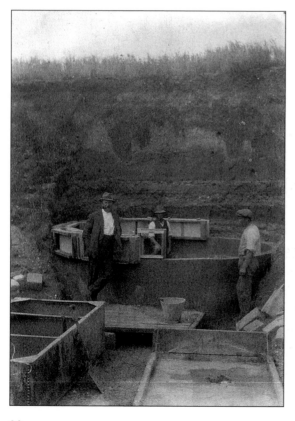

Brundon Hall Farm was owned by Mr Cecil Whittome, seen here (with pipe) supervising the construction of one of the first concrete silos in the country. Completed in 1920, it still stands close to Jordan's pit.

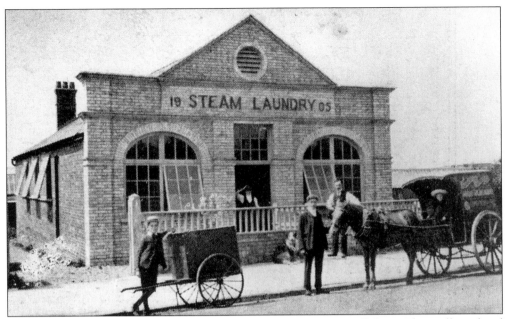

Sudbury Steam Laundry opened in 1905 in Queens Road and it is still there. They collected and delivered by handcart and horse-drawn carts at first but soon went over to motor transport.

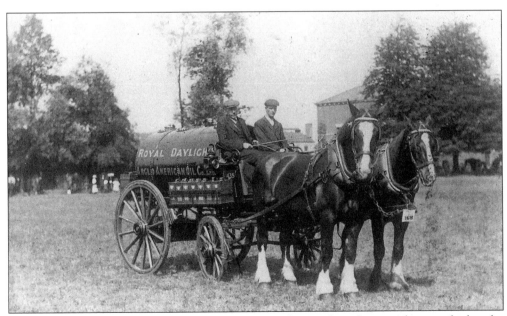

'Royal Daylight' oil was delivered by horse-drawn tankers such as this one photographed at the Quay.

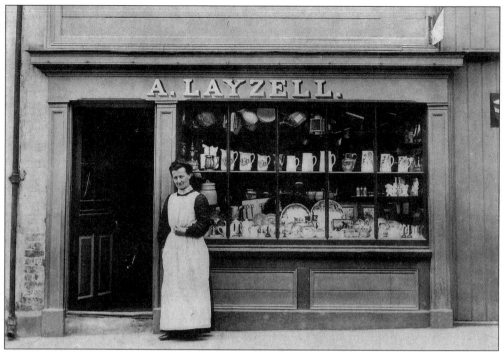

Layzell's hardware shop was in Cross Street alongside No. 78. The goods displayed in the window would now be much sought-after antiques. As business boomed they moved to larger premises in Friars Street. Much of their success was because they ran a mobile shop which toured the villages.

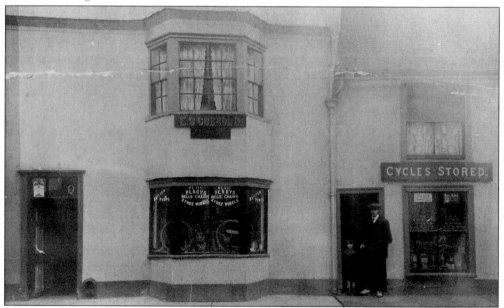

In the 1920s, with very few cars on the roads, most people used cycles to get about. Today, we are being urged to return to that habit! Mr Cobbold's cycle store in Friar Street was very popular with visitors who could hire a machine for the duration of their stay at a reasonable cost. Perhaps we can expect a revival in such businesses?

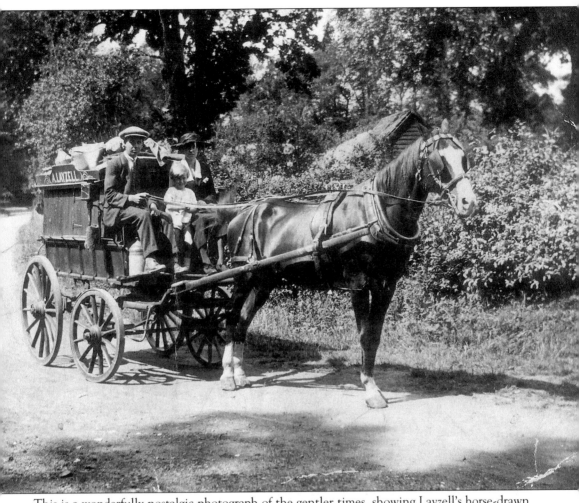

This is a wonderfully nostalgic photograph of the gentler times, showing Layzell's horse-drawn mobile shop with driver, his wife and son in the early 1920s.

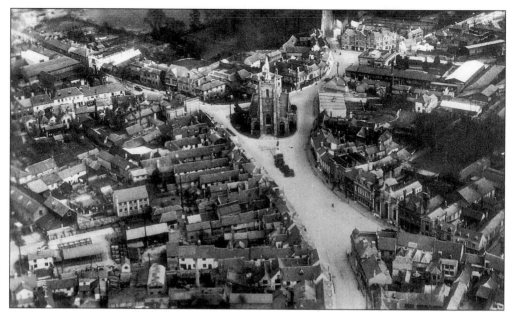

The motor car was to have a devastating effect on the town centre. This is a postcard view of 1930 with only eight vehicles on the road. The Market Hill is beginning a new phase as a car park except on market days.

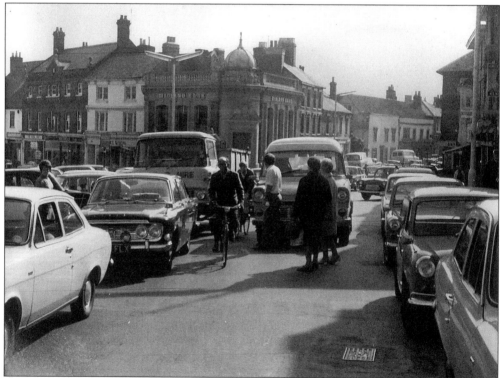

By the 1960s road traffic had become a very serious problem and something had to be done, if possible with the least amount of damage to the town's historic core. It was a problem shared by similar country towns and one that is still unsolved.

Nine
1960s Town
Improvements

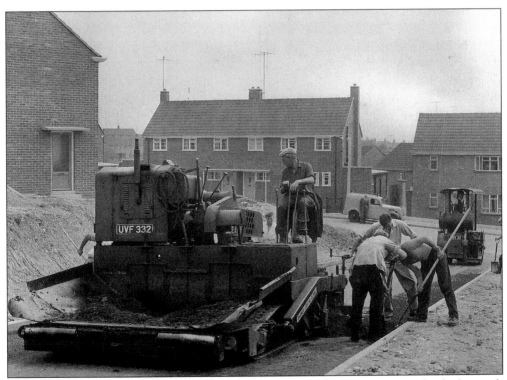

Throughout the 1960s new housing estates came into being, transforming completely the north and east of Sudbury. Woodhall was built on high ground off the Melford Road on the edge of town, but now even that has been completely encircled as the town continues to grow.

Gregory Street is one of Sudbury's oldest streets. By the middle of the nineteenth century it was narrow and lined with brick terraces of three-storey weavers' houses. All of them were demolished including those on The Croft and Church Walk. Just a small group of cottages remain by the church gate to indicate the original line of the street. All traffic into the town from the south now flows along the widened thoroughfare, which is now a major part of the one-way system.

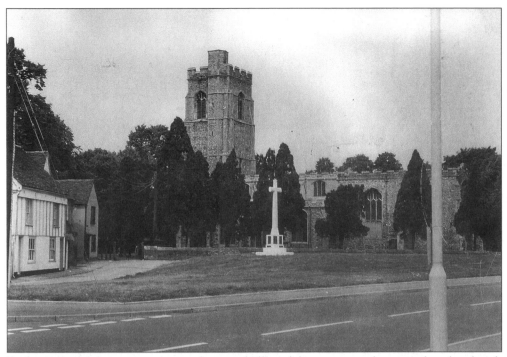

Realignment of the street at its northern end allowed for a green to be created at the church gate. On it was placed the war memorial, which had stood at the top of North Street. Compare this with the previous photo and the scale of the 1960s clearance is clearly shown.

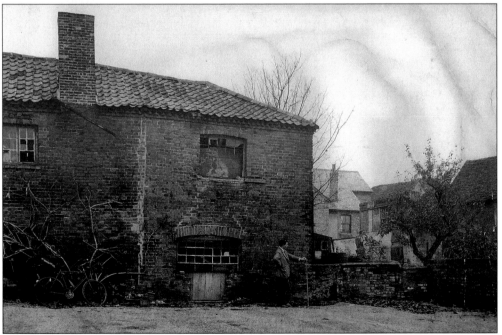

One of the features of nineteenth-century Sudbury was the journeymen's yards, which were hidden away behind the main streets and approached by narrow passageways. Goody's Yard, off North Street, was one of many which vanished in the 1960s.

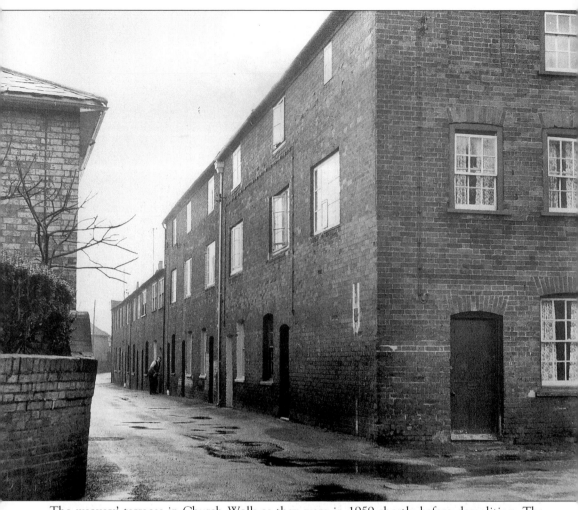

The weavers' terraces in Church Walk as they were in 1959 shortly before demolition. The large windows on the first floor were to light the loom. Such houses can be seen in other Sudbury streets, especially in East Street where they have been adapted for modern living. They form an important part of the town's industrial heritage.

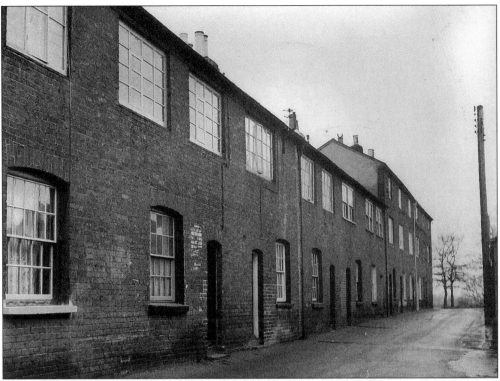

Another view of Church Walk. There was a strong feeling in the town that too many houses of this type were being demolished. The last terrace to be removed was Inkerman Row when it was thought that the site would be suitable for a new Town Hall, anticipating wrongly that Sudbury would be the headquarters of the newly formed Babergh District Council. That honour went to Hadleigh instead.

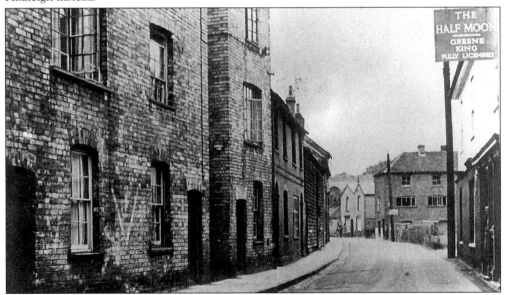

Gregory Street in 1960, looking towards the church. Every building in this photograph has been demolished and the road is now twice the width.

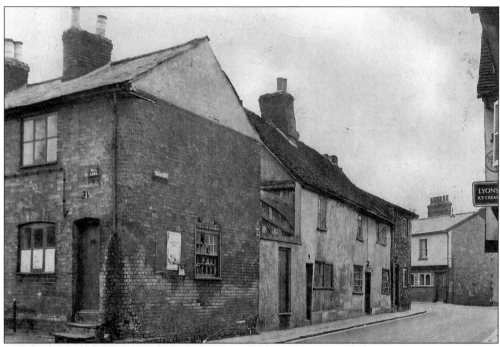

These cottages, Nos 1 and 2 Cross Street, were demolished in 1958 for road widening and the provision of a small car park. The whole of Mill Lane was to go a few years later.

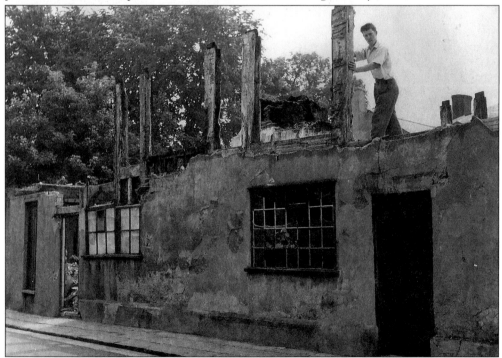

Demolition revealed the fourteenth-century timber frame of a medieval hall house. No attempt was made to number and retain the timbers for re-erection elsewhere, which would probably be the case today.

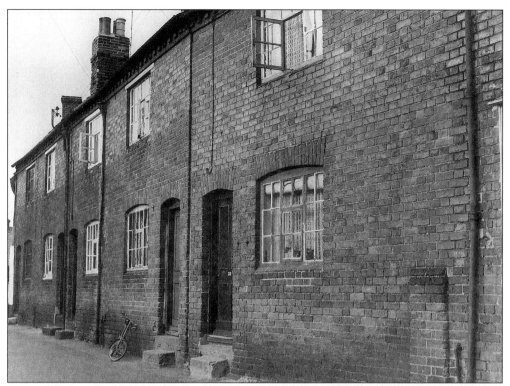

The cottages in Mill Lane were cleared because they were considered sub-standard. Today such houses in a quiet town centre lane would be eagerly snapped up and converted for modern use.

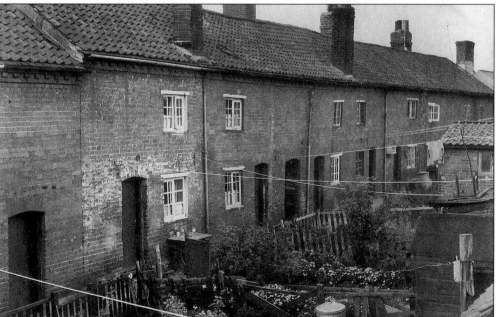

The rear view of Mill Lane is particularly interesting because subsequent excavations have revealed that they were built on the site of medieval houses exactly on the edge of the Saxon/Norman town ditch, hence the gentle curve.

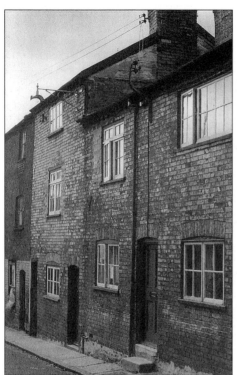

Plough Lane is an old Norman thoroughfare and one of the oldest in the town. Several of the cottages that line it have medieval interiors. Numbers 13-16, seen here in 1960, were Victorian and considered sub-standard. Fortunately the remainder of Plough Lane has remained intact.

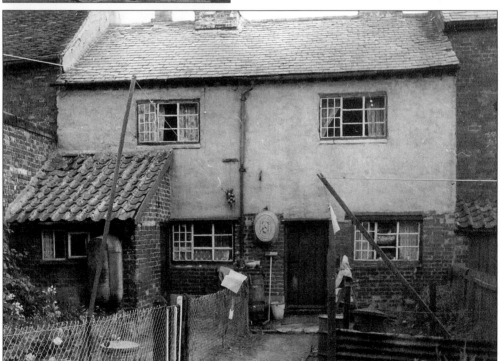

A rear view of 15-16 Plough Lane. The tin baths on the wall indicate the absence of bathrooms. There was enough space to overcome that defect with the construction of an extension, which would be more likely to happen today.

The rear of Siam Gardens, small bungalow dwellings off Gaol Lane. They were cleared to provide rear traffic access to North Street and additional car parking.

These cottages in Lion Walk were demolished for the same reason. Lion Walk was named after the inn which later became the Four Swans. The residents had pedestrian access to North Street through the inn yard.

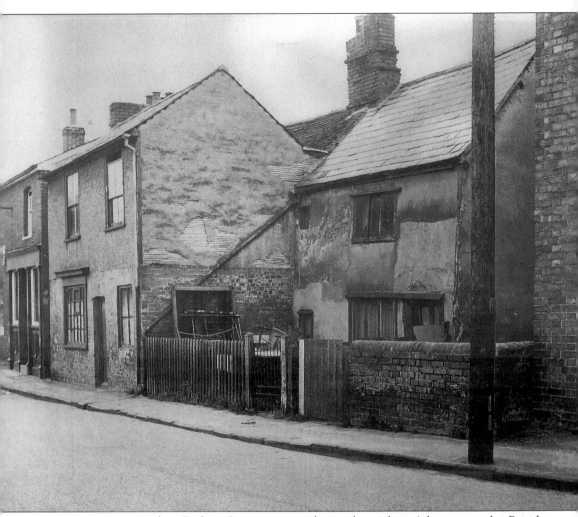

These cottages stood in Burkitts Lane opposite the cattle market. Adjoining is the British Volunteer, which came into its own on market day. All were cleared in the 1960s and the sites remain vacant. Like the cottages in Mill Lane, these stood on the line of the Norman town ditch. The pattern of the Sudbury streets tells more about the antiquity of the town than the buildings which line them.

With Girling Street about to become an important part of the proposed inner relief road, these houses had to go. Cundy's seed warehouse on the left has since become a snooker hall.

Girling Street in 1964, looking towards East Street, where the new section of the inner relief road would cut through to Kings Street. The houses on the left are those in the previous picture.

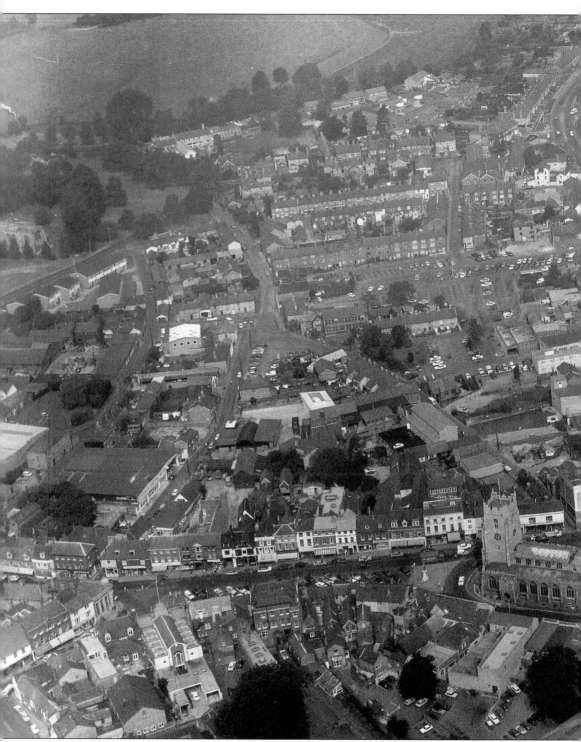

An aerial view of Sudbury town centre in 1972. The new section of the inner relief road from Girling Street to King Street is seen on the far left. At one time it was proposed to demolish the Bear Inn to enable the road to link up with Great Eastern Road. North Street has yet to be

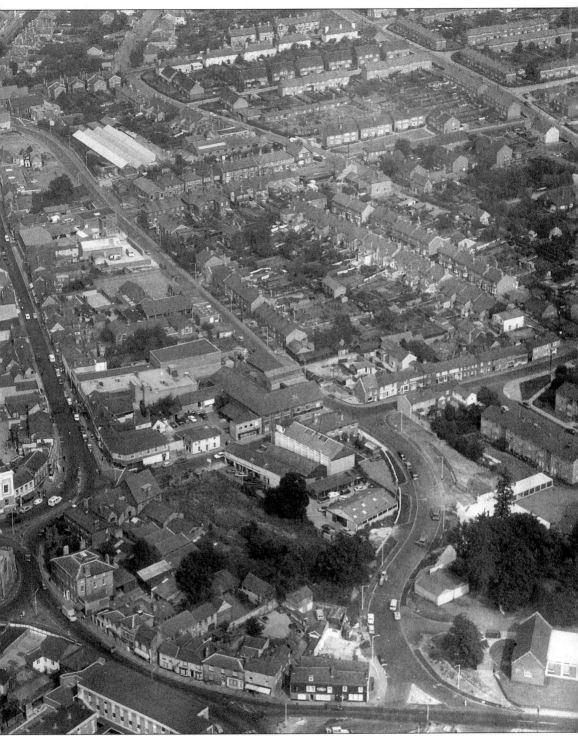

closed off at the top end and is still carrying two-way traffic. The spire has been removed from the church and the upper stage of the tower has been rebuilt. East House has gone to make way for a new post office.

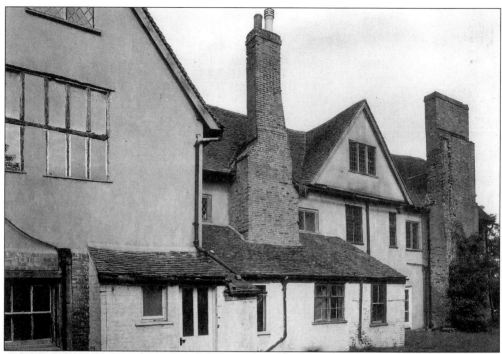

An extraordinary event in 1972 captured the imagination of the world. Ballingdon Hall, the surviving cross-wing of a great Elizabethan manor house, had been surrounded by a new housing estate and industrial warehousing. The owner decided to move house – literally! This photograph shows the rear view before the chimneys were dismantled prior to moving the house further up the hill.

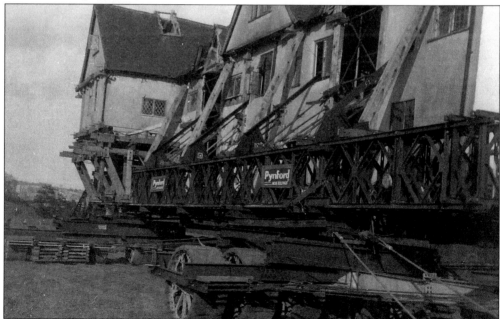

The house was raised on a Bailey construction and winched up the hill. Not a tile fell off the roof during the zigzag journey to a new site 200 yards away.

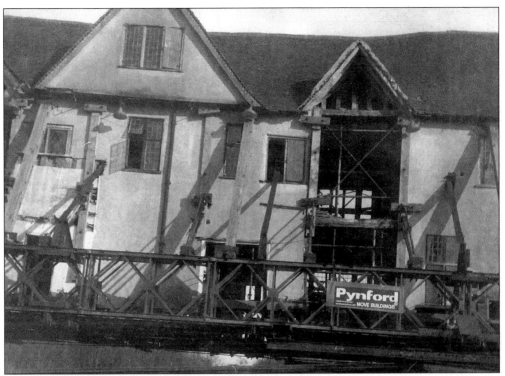

The move was a triumph for Pynfords who moved it but also a resounding tribute to the original builders of the huge timber-framed building whose perfect joinery made it possible. The opening visible here marks the position of a chimney.

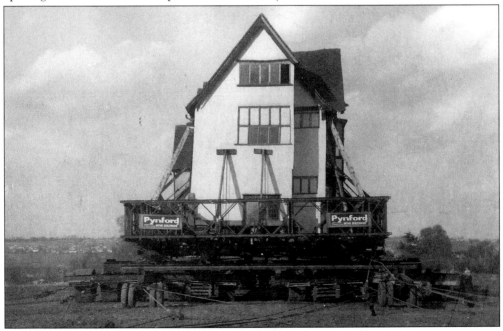

Hundreds turned up to watch the great house on the move like a giant liner leaving Southampton. Millions watched it on television.

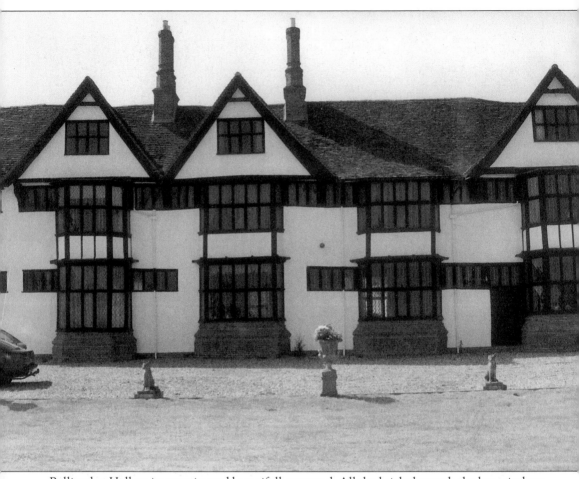

Ballingdon Hall on its new site and beautifully restored. All the bricks beneath the bay windows were dismantled and numbered. The chimney stacks have been repositioned and are no longer along the back of the house. All the windows beneath the eaves have been uncovered and the roof appears to float on glass.

With the creation of new industrial estates and Woodhall and Springlands housing estates, a northern bypass was needed; it was built in 1970.

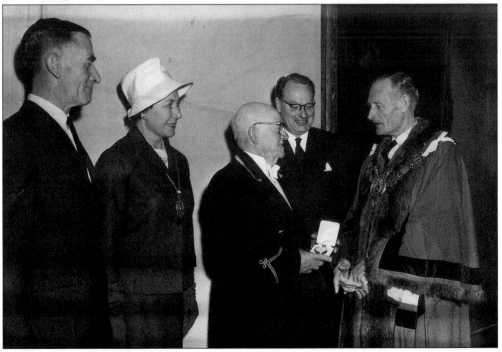

In 1967, Mr F. Cresswell retired as Mace Bearer for the old Borough Council and was presented with a watch to mark the occasion. From left to right: Cllr W.R. Barker, Mrs Brunhilda Wood (Mayoress), Mr Cresswell, Cllr B. Eady and Cllr Stanley Wood (Mayor).

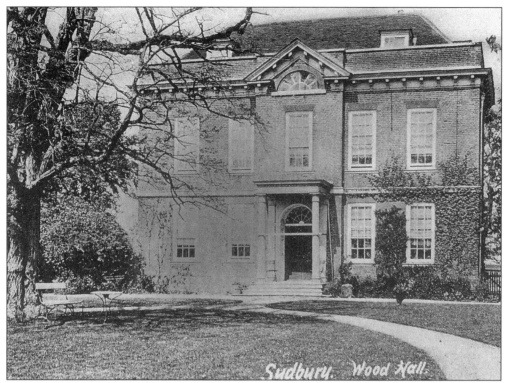

Wood Hall, an ancient manor house on the north side of Sudbury, was less fortunate during the war, as a fuel tank jettisoned from an incoming plane landed on it. Though patched up for some years, it was finally demolished in the 1960s.

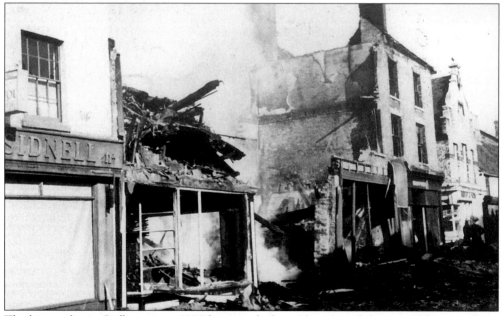

The biggest fire in Sudbury since 1922 happened when Alston's and three neighbouring shops were destroyed in North Street.

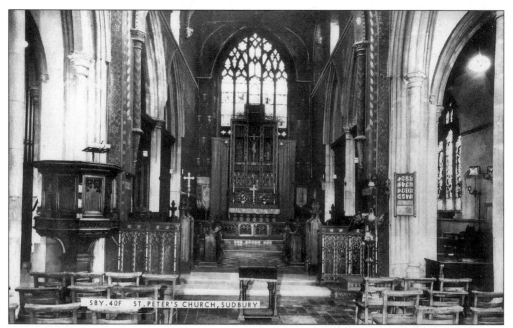

A service of thanksgiving was held in St Peter's church following the complete restoration of the chancel. This had involved the removal of much of Bodley's decoration and opinions still differ concerning the wisdom of that action.

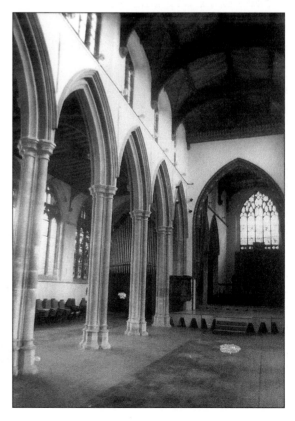

After further costly restoration work, including the rebuilding of the top stage of the tower, the church was declared redundant on 30 March 1972. In 1976 it was formally vested in the Redundant Churches Fund. The Friends of St Peter's was formed and has done sterling work to protect the building and promote its use for concerts and exhibitions. It is still a consecrated building and the occasional service is still held.

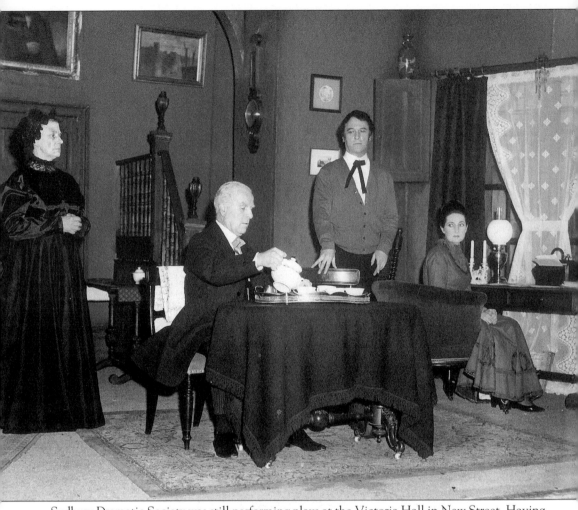

Sudbury Dramatic Society was still performing plays at the Victoria Hall in New Street. Having increased the number of productions per year, a great deal of their funds were spent on hiring rehearsal rooms and storage space. Eventually they took the brave step of buying their own premises. One of the last productions at the Victoria Hall was *The Late Edwina Black*. From left to right: Joan Jamieson, Arthur Poore, Andrew Aitken and Gillian Bell.

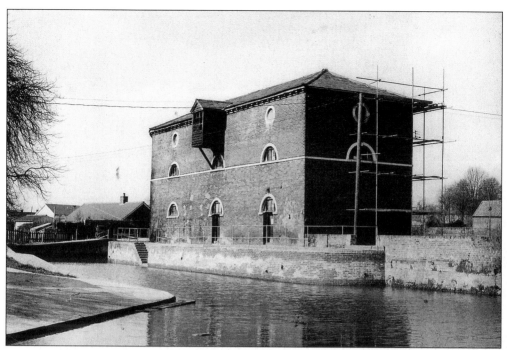

The conversion of an eighteenth-century warehouse at the Quay into a theatre by the Sudbury Dramatic Society has been one of the great success stories of the town's recent history. The building was acquired in 1977 and it was opened officially by Max Wall in 1981. These photographs show the building in the early stages of conversion.

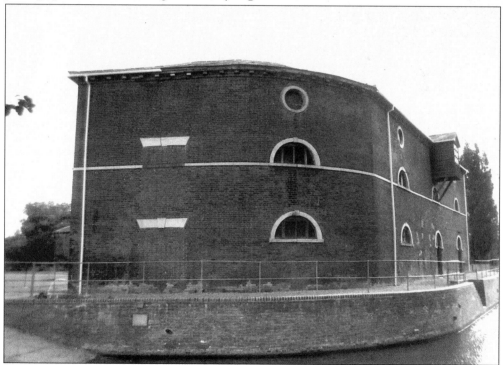

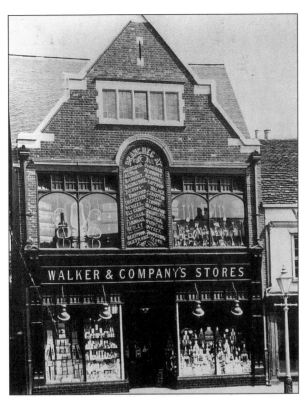

Walker's Stores had been trading in Old Market Place for fifty years in a building on the site of the George Inn. It closed in the late 1960s.

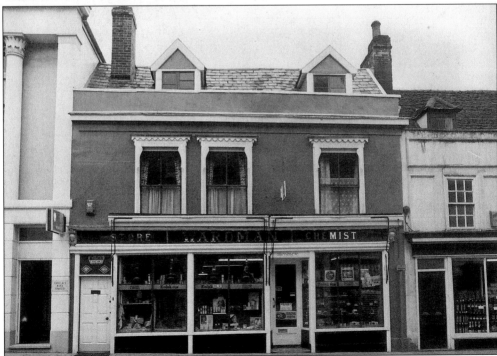

Sudbury's last independent chemist's shop closed with the retirement of Mr John Wardman. It was opened in 1825 and closed in 1975.

Ten
Early Schooldays

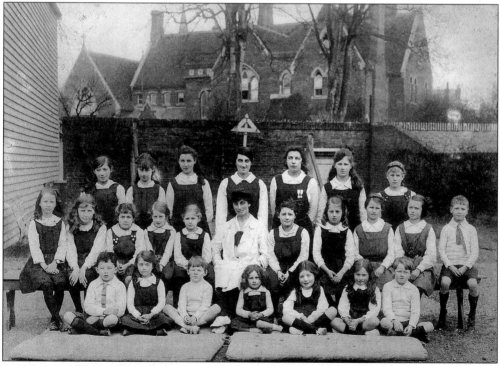

At the turn of the century there were at least four private schools in Friars Street. Here, pupils and staff of the Limes Preparatory School pose for the photographer in around 1916. In the background is Sudbury Grammar School over the wall in Christopher Lane.

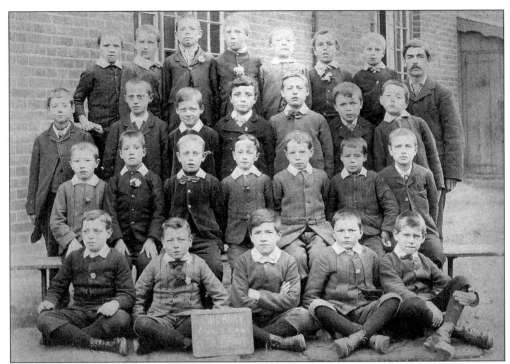

Early school photographs are always interesting, but sadly we seldom if ever have names to put to faces. A class of boys from the Sudbury Church School, better known as North Street School, pose here in 1899 or 1900. Only the inscription on the slate allows us to identify it as such.

Similarly, this group of lads photographed in 1904-05 desperately cry out for identification. The inscription simply states 'Sudbury Free Church'. However, these faces look remarkably modern as the century draws to a close.

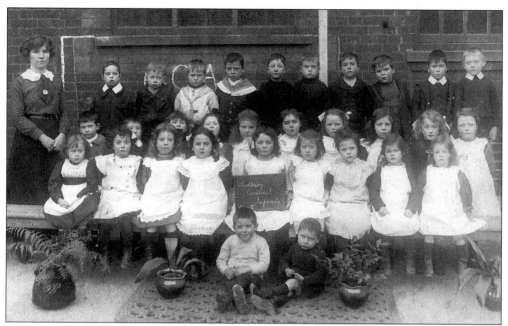

Sudbury Council School was in Mill Lane and became the Sudbury Secondary Modern School in the mid-1940s. This is class II of 1913 with only one of the children actually smiling – at the centre front.

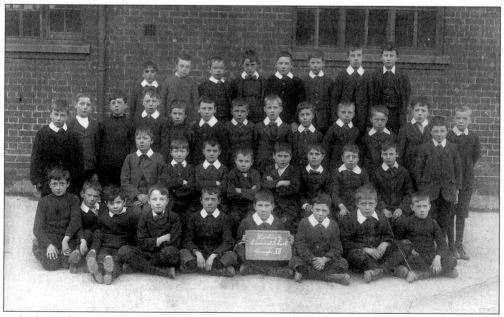

Nobody smiles in Group III either but close study shows some attempt at a school uniform. These lads were just too young to become soldiers in the First World War, which was to break out in the following year.

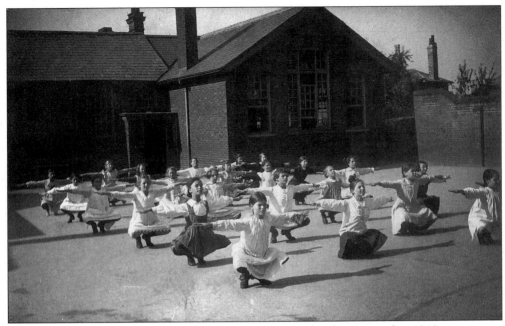

These girls are going through 'drill' at Sudbury Council School in September 1919.

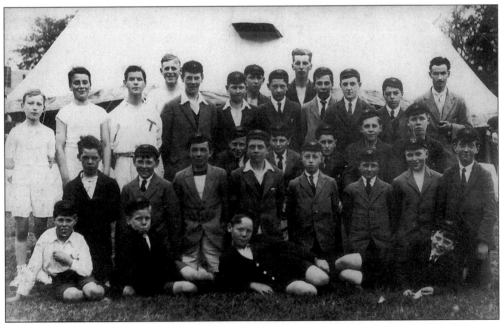

Boys from Taylor House, Sudbury Grammar School, pose with their housemaster, Mr H Brown, c. 1925. The two lads in the front row, extreme left, seem to be up to no good.